SOUTHEAST ALASKA
EARLY PHOTOGRAPHS OF THE GREAT LAND

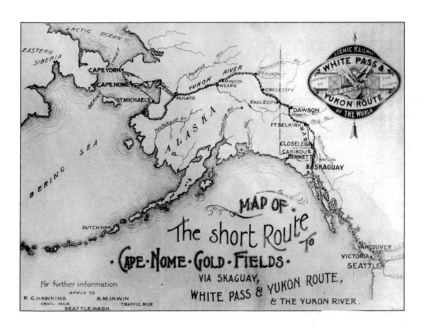

Graham Wilson

Digital Pre-Press by
 Joel Edgecombe
Edited by Clélie Rich,
 Rich Words Editing
 Services, Vancouver, BC
Design and Production by
 Wolf Creek Books Inc.
Printed and Bound by
 Friesen Printers, Altona,
 Manitoba, Canada

Canadian Cataloguing in Publication Data

Wilson, Graham 1962-
Southeast Alaska,
Early Photographs of the
Great Land.

Includes index.
ISBN 0-9681955-4-7

1. Southeast Alaska--
History--Pictorial works. I.
Title.

F905.W54 1998
917.9804'51
C98-900381-7

Acknowledgements

This book is the product of
many skilled and supportive
people. Interpreters with
the Alaska National
Historical Association were
extremely helpful with the
research of this book. Anne
Chandonnet provided
important historical and
cultural details and greatly
improved this publication.

**WOLF CREEK
BOOKS INC**
Box 31275,
211 Main Street,
Whitehorse, Yukon
Y1A 5P7
info@wolfcreek.ca
www.wolfcreek.ca

Joel Edgecombe, using con-
temporary digital pre-press
tools, enhanced the quality
of images that are in many
cases more than a hundred
years old. John Small
accessed the resources
required for this publication
and provided much encour-
agement and enthusiasm
towards this project. Finally,
Lauren Crooks and Emily
and Jessica Wilson were very
understanding when I spent
evenings and weekends
working on this project.

About the Author

Graham Wilson has lived in
the north for more than a
decade. He is the author of
several books including *The
Klondike Gold Rush:
Photographs from 1896-1899*,
*The White Pass and Yukon
Route Railway*, and
*Paddlewheelers of Alaska and
the Yukon*. Graham is keenly
interested in historic pho-
tographs and the stories that
they tell.

CONTENTS

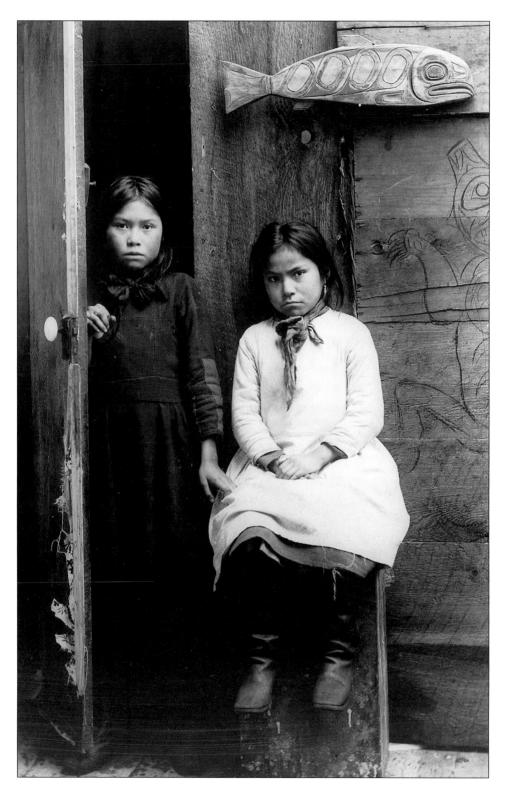

THE FIRST PEOPLES

Southeast Alaska is a region of mist-shrouded islands and fjords. Snowcapped mountains sporting massive glaciers form an impressive backdrop to this rugged landscape. The dense, almost impenetrable, rainforest crowds mountains from the snowline to the edge of the Pacific. It is one of the rainiest places in the world with some areas receiving more than a hundred and fifty inches of precipitation a year. Summers tend to be relatively warm and winters, by northern standards, are mild.

Indians have lived in Southeast Alaska for at least 8,000 years. The Tlingit, Tsimpsian, and, more recently, Haida established sophisticated societies with unique languages, arts and cultures. Most of Southeast Alaska was inhabited by the Tlingit, a maritime people who relied on fishing, hunting and trading. While the rich annual salmon run formed the basis of their economy, they also hunted seals, whales, moose, sheep and goats as well as birds and freshwater fish. Wild berries were collected as were various herbs and vegetables.

The Tlingits established permanent villages with communal houses. They also had seasonal camps such as fishing camps, to exploit the various seasons of food gathering. Totem poles and clan crests made of cedar stood along beaches and in front of buildings. These elaborate carvings indicated the social standing and material well-being of the clan. Despite having permanent villages, Tlingits were famous long-distance traders. They traveled in meticulously carved cedar canoes which were often more than sixty feet in length. The large upswept bow cut through the largest waves, and with several people paddling, these vessels were both stable and quick. Trading frequently took the Tlingits to the Puget Sound and sometimes as far south as Mexico. They also traveled north to trade with other native peoples such as the Alutiiq.

Traveling inland along the great rivers such as the Taku and Stikine allowed Tlingits to gather furs from an impressively large region. To travel upstream they added-

Two Tlingit Indian girls beneath a traditional salmon carving, and a bear incised on the wall to the right.

5

large sails to their canoes which carried them hundreds of miles inland relatively effortlessly. These trade journeys were extremely important to many interior Athapascan Indian peoples as they coveted the rich oil of the coastal Eulachon fish.

The adventurous lifestyle of the Tlingit is reflected in their art. They were a cosmopolitan people who valued art and culture. Tlingits created elaborate stories, songs and poems of great complexity and creativity. They also crafted bentwood boxes and ceremonial objects such as masks, rattles and bowls. Grasses and bark were crafted into woven hats, clothing and baskets. Perhaps most sought after is the Chilkat Blanket which sometimes took expert weavers years to craft from wool from the underside of mountain goats.

The first contact with Europeans was likely with the Russians in the 1740s. The Russians sought the highly valuable sea otter pelt and brought Alutiiq Indians to hunt for them in Southeast Alaska. The Alutiiq hunted from agile baidarkas, a type of long kayak. The sea otter population was quickly diminished by this intensive hunt.

The relationship between the Russians and Tlingits was always tense. In 1802 Tlingits invaded Redoubt St. Michael, a Russian village a short distance from modern Sitka. Almost all the Russians and Alutiiq at this settlement were killed. In retaliation the Russians returned to Sitka in September 1804. Four gunships entered the harbor and demanded the Tlingit surrender. Instead the Tlingits withdrew to the safety of their fort. The Russians bombarded the fort with cannon fire for the next six days. The Tlingits had anticipated this exchange and had constructed the fort's walls from heavy timbers which were not penetrated by cannonfire. Russian and Alutiiq soldiers stormed the fort but were driven back to their ships by fierce hand-to-hand combat. The well armed and skillful Tlingit were capable soldiers and inflicted serious Russian and Alutiiq casualties.

Early on the morning of the seventh day of the siege the Tlingits secretly fled the fort and disappeared into the rainforest. The siege of Sitka was over. The Russians

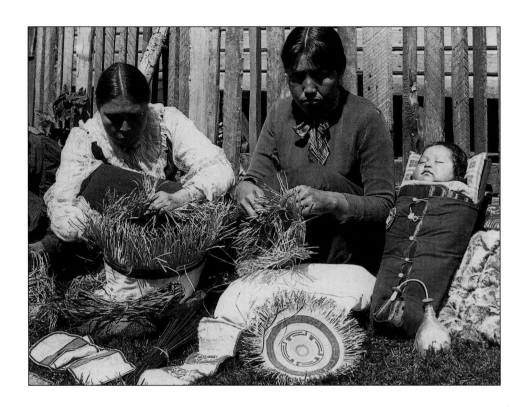

Above: Two Tlingit Indian women, with a baby, weaving baskets in Sitka. Baskets were woven from grasses and spruce roots which were often dyed. Certain types of baskets were woven so tightly that they were used to hold water. Basketry was a well developed art incorporating complex designs and patterns.

Pages 8 and 9: The Whale House in Klukwan had carved posts, panels, bentwood boxes and other ceremonial objects. Here a group of Tlingits pose in woven hats, masks and elaborate Chilkat dancing blankets woven from mountain goat wool. The boy is wearing a cedar bark neck ring. The huge, unadorned woven basket at lower left was probably used to store ceremonial regalia.

quickly established their foothold by building a fort of their own.

In 1821 the Tlingits were invited to return to their ancestral home of Sitka. The Russians wanted to end the occasional skirmishes which had plagued the "peace" and to benefit from Tlingit trading and hunting. The new Tlingit community was established outside the stockade in an area known as the "Ranche." The Tlingit could be easily monitored from the stockade and a cannon could be easily trained on them. The relationship between the Tlingit and Russians was always strained but after the Tlingits returned to Sitka, the relationship became more amiable.

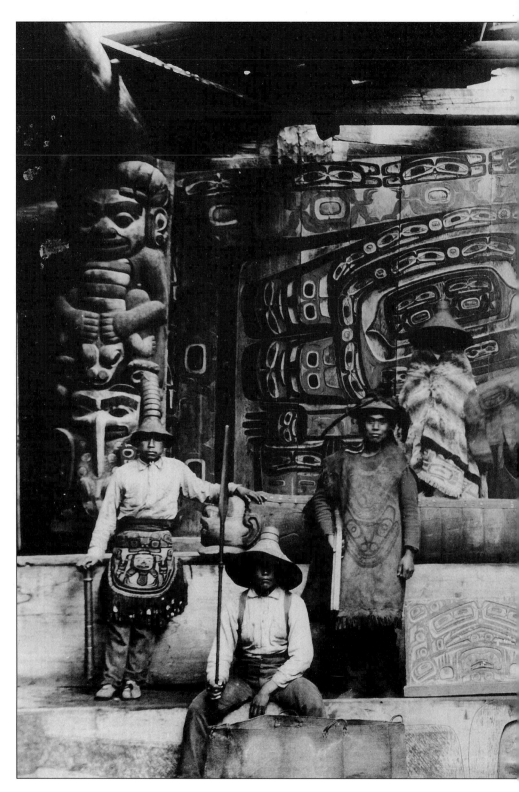

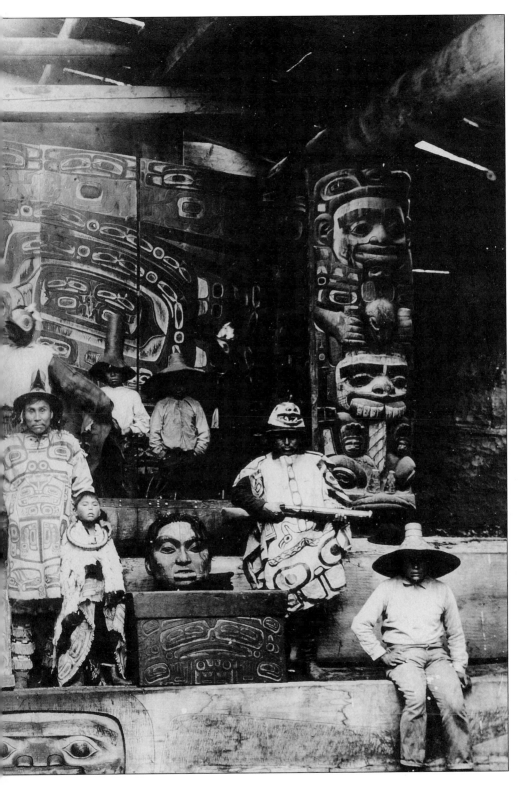

9

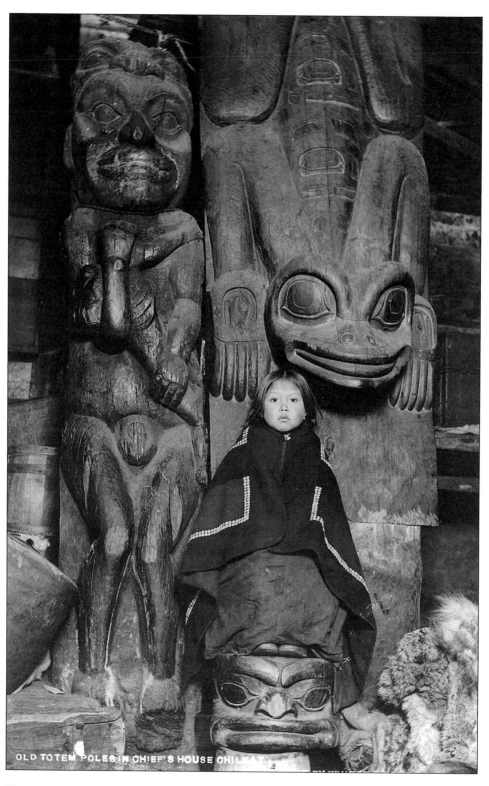

OLD TOTEM POLES IN CHIEF'S HOUSE CHILKAT

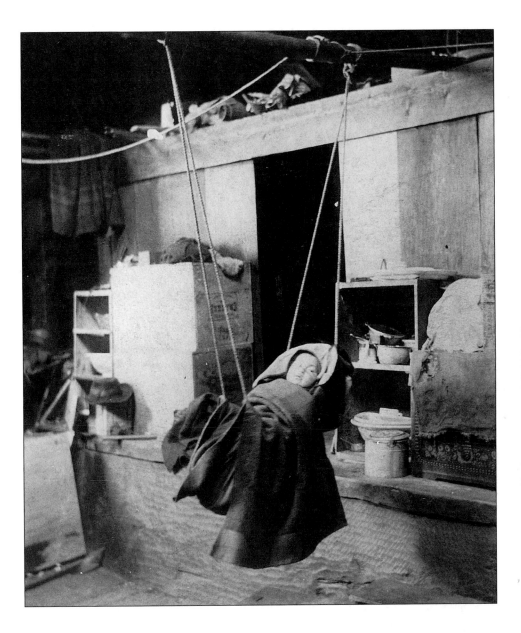

Opposite: A young girl poses in the Frog House in Klukwan. She is wearing a traditional button blanket trimmed with mother-of-pearl buttons. The girl is sitting on a carving of a head in front of a totem pole and a wooden house post carved in the form of a frog.

Above: A baby in a cradle suspended from a beam in a traditional Tlingit longhouse.

Pages 12 and 13: The elaborate totem poles of the Haida village of Howkan provide a glimpse of nineteenth century coastal Indian life. The carved men with tall hats on the totem at left are "watchmen." An unusual representation of an orca whale with two dorsal fins can be seen at the top of one of the totem poles in the center. On the beach are several Indian canoes with raised carved bows made from enormous hollowed-out cedar trees.

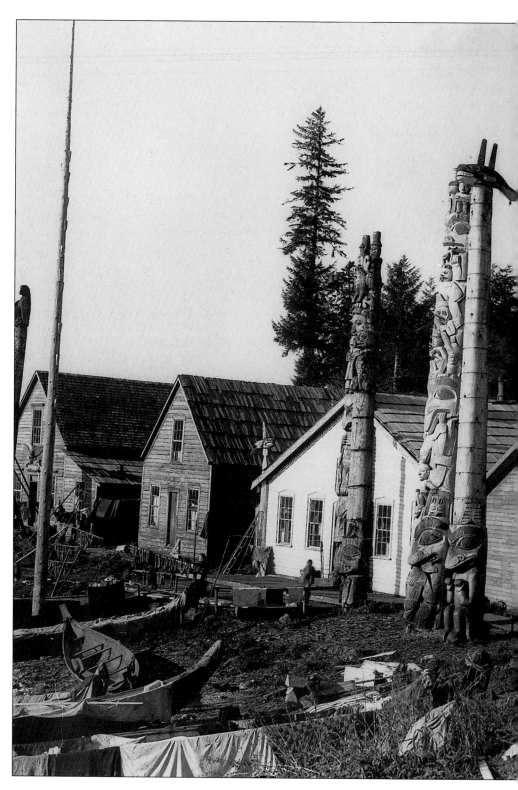

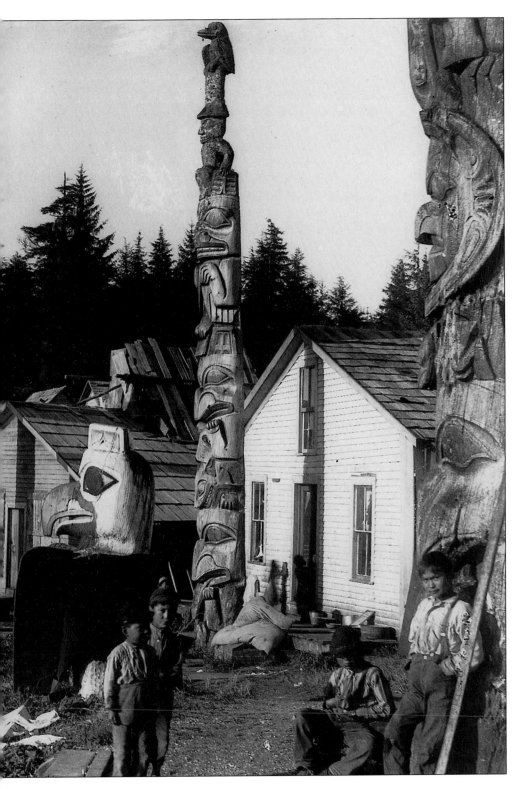

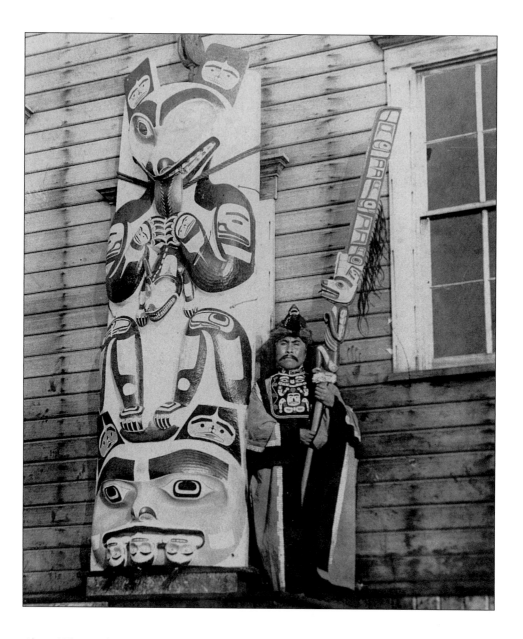

Above: A Tlingit Indian poses in a dancing blanket and hat beside a complex totem pole. The staff marks him as "speaker of the house."

Opposite: Chilkat Indians arriving in Klukwan for a potlatch. They are pulling cedar canoes up the Chilkat River to the community. ca. 1900.

Pages 16 and 17: The Haida Indian village of Klinquan with beached canoes. The large buildings sometimes housed several families each. Klinquan was located on the southern tip of Prince of Wales Island.

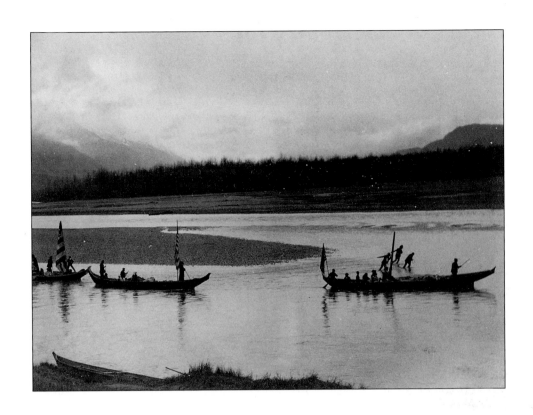

Once, while I sat sketching among the icebergs, two Tahkou Indians, father and son, came gliding toward us in an exceedingly small cottonwood canoe. Coming alongside with a good-natured "Sahgaya," they inquired who we were, what we were doing, etc., while they in turn gave information concerning the river, their village, and two other large glaciers a few miles up the river-canyon. They were hunting hair-seals, and as they slipped softly away in pursuit of their prey, crouching in their tiny shell of a boat among the bergs, with barbed spear in place, they formed a picture of icy wildness as telling as any to be found amid the drifts and floes of Greenland.
John Muir, 1897

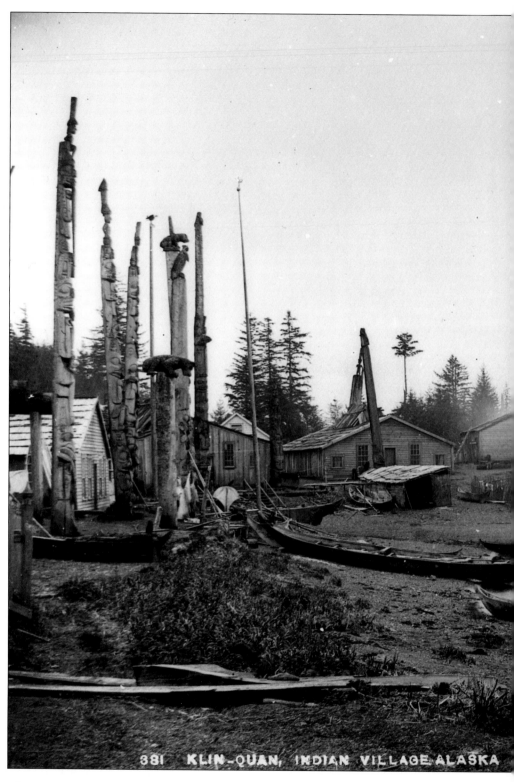

881 KLIN-QUAN, INDIAN VILLAGE ALASKA

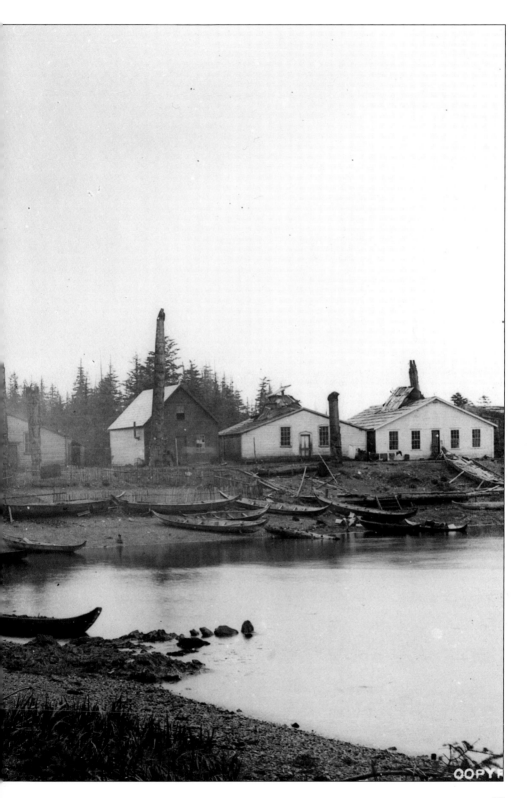

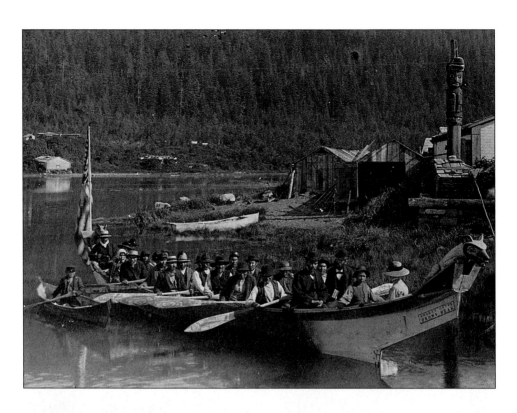

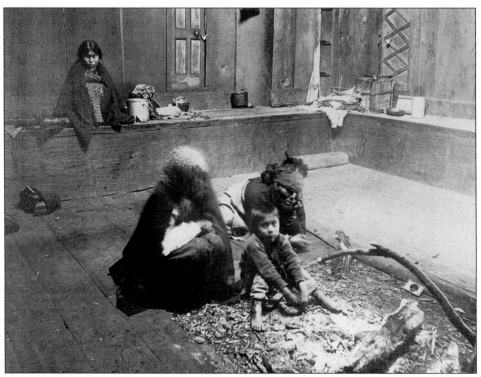

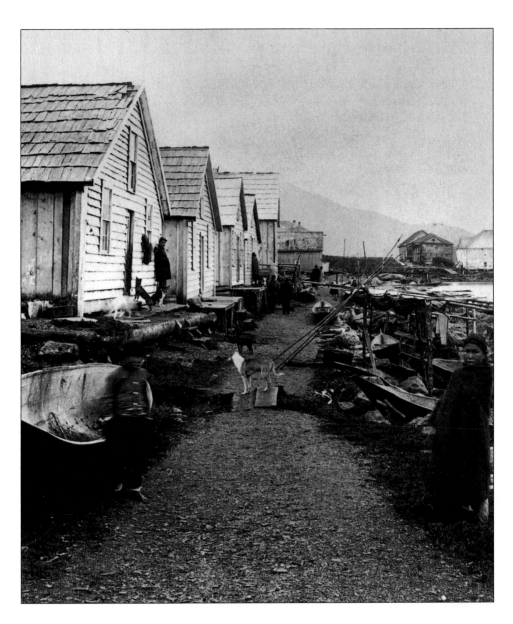

Opposite Top: Tlingit Indians in Chief Shakes' canoe with a bear carving on its bow. The canoe is landing at Wrangell, the home of Chief Shakes in his later years.

Opposite Bottom: A Tlingit Indian family in a longhouse at Sitka.

Above: The Indian Village in Sitka.

The distinctive ceremonial robe of the several native tribes of the North Pacific coast, from Vancouver Island to Prince William Sound, is commonly known as the "Chilkat blanket" - an exquisite piece of weaving in wool, as harmonious in coloring as it is in original in design, presenting in all of its features the highest development of the textile art throughout this region, and comparing favorably with the best productions of other lands.
George T. Emmons

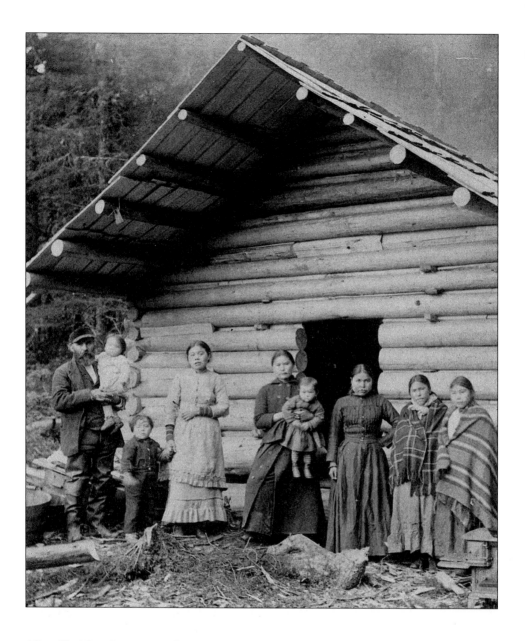

They [the Tlingit] manage to feed themselves well, build good substantial houses, bravely fight their enemies, love their wives and children and friends, and cherish a quick sense of humor. The best of them prefer death to dishonor, and sympathize with their neighbors in their misfortunes and sorrows.

John Muir, 1897

Above: A non-native settler likely with his Tlingit wife and her relatives dressed in their finest clothes. ca. 1887.

Opposite: Tlingit Indians with two totem poles in Wrangell, May 2, 1889.

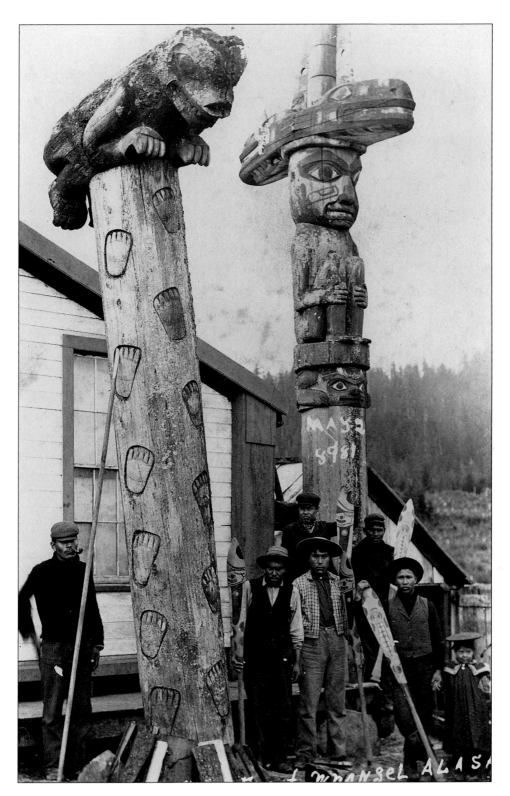

WRANGEL ALASKA

21

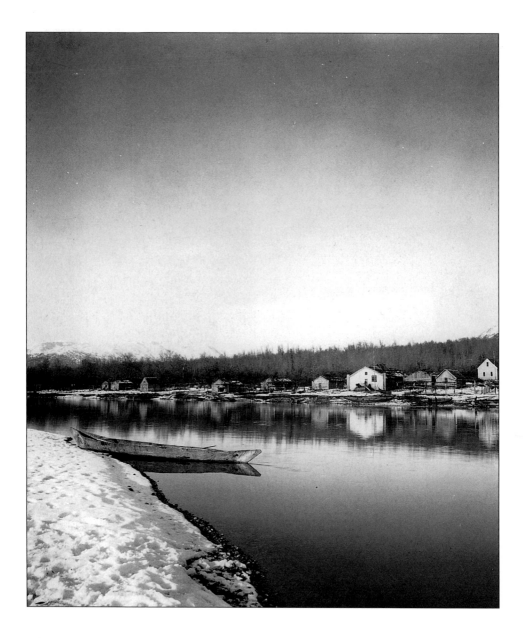

The Indians are adept in taking halibut, and use hooks of native manufacture, made of bone or of wood and iron, which are far more efficient than any shop rig. White fishermen who have tried them will use no other, for a fish who once bites seldom gets away. Some are beautifully carved.
Charles Hallock, The Outing Magazine, 1908.

Above: Chilkat Indian village of Klukwan near Haines. Klukwan remains an important Chilkat village to this day. ca. 1895.

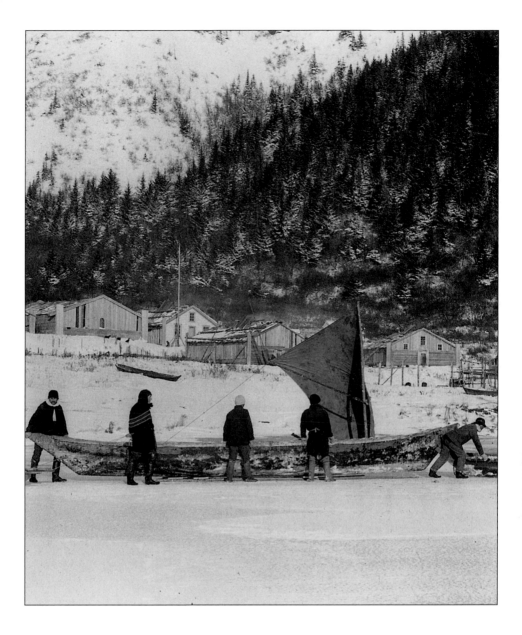

Above: Chilkat Indians using sails to move canoes on the frozen Chilkat River at Yindastuki. ca. 1895.

Page 24: A Tlingit man posing in a Chilkat dancing blanket. On his head is an intricate carved wooden frontlet of a bird with abalone eyes, *fringed with ermine pelts and sea lion whiskers*

Page 25: A Tlingit man posing in a Chilkat dancing blanket. These blankets were woven from mountain goat wool and dyed with lichen, various plants and other natural substances.

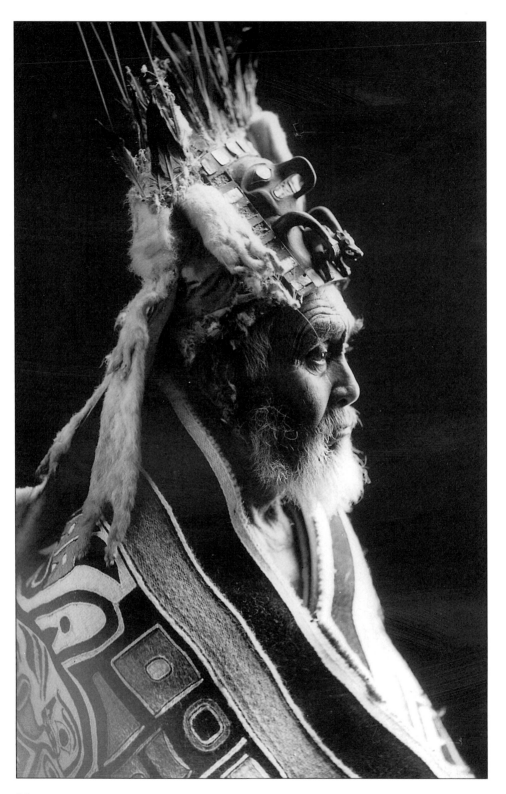

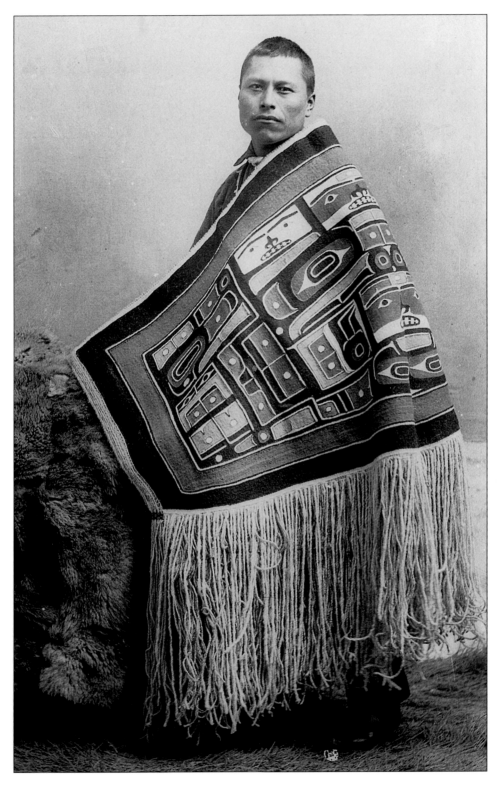

25

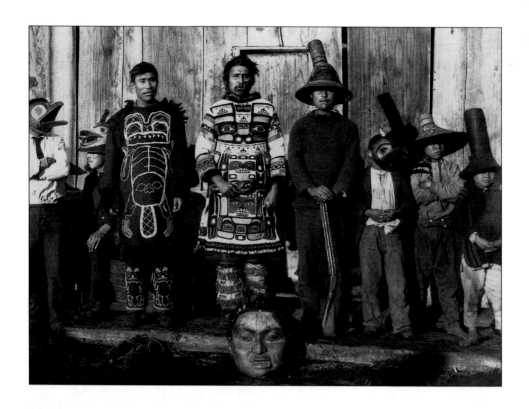

In constructing the native cabin, the planks are set on edge and so nicely fitted that they need no chinking. The shape of the house is square; a bark roof is laid on, with a central aperture for chimney. The door is a circular opening about two feet in diameter. It is closed with a sheet of bark or a bear-skin or seal-skin.
Century Magazine, July 1882

Above: Indians at Klukwan pose in ceremonial clothing, including a tunic with a beaver design, left. Several men wear woven and painted hats and carved wooden masks. The rings woven onto the tall spruce root hat indicate pot-latches that the owner has given. A large carved wooden head is in front.

Opposite: Two Tlingit men pose in button blankets holding carved wooden ceremonial objects, probably rattles. ca. 1888.

Pages 28 and 29: Chilkat Indian dancers at a potlatch at Klukwan. Some of the men hold dance fans made of white feathers. Potlatches were important community gatherings which adhered to complex traditions and often took several days. ca. 1895.

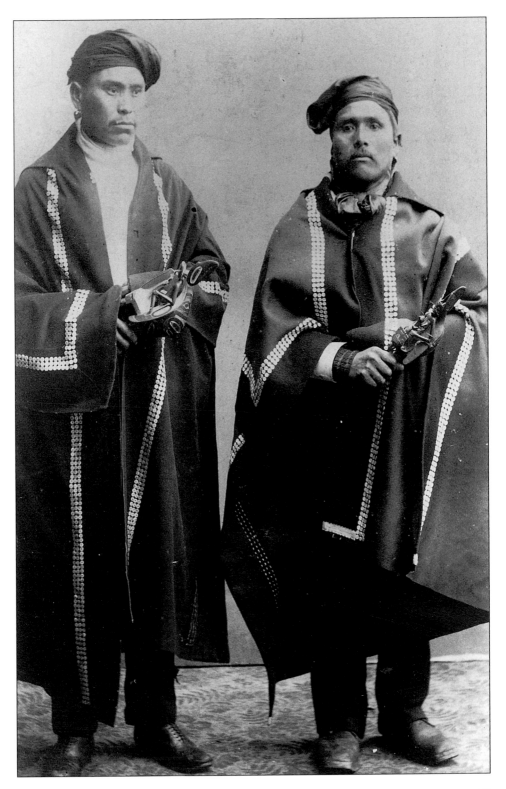

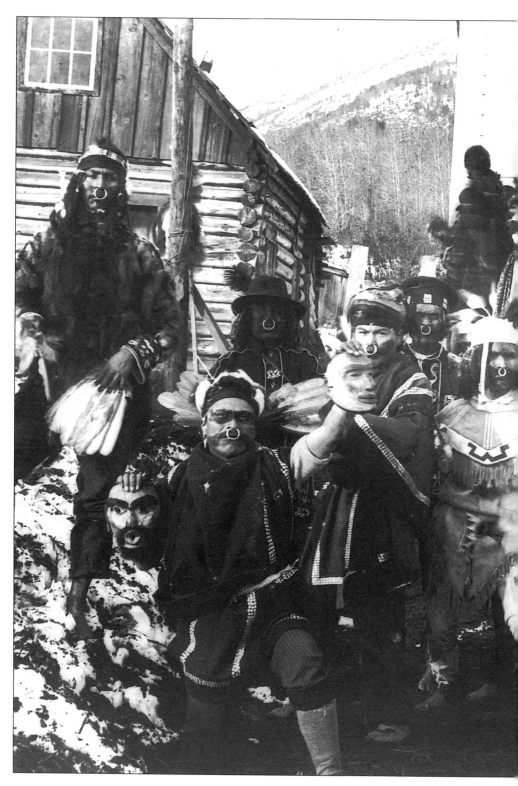

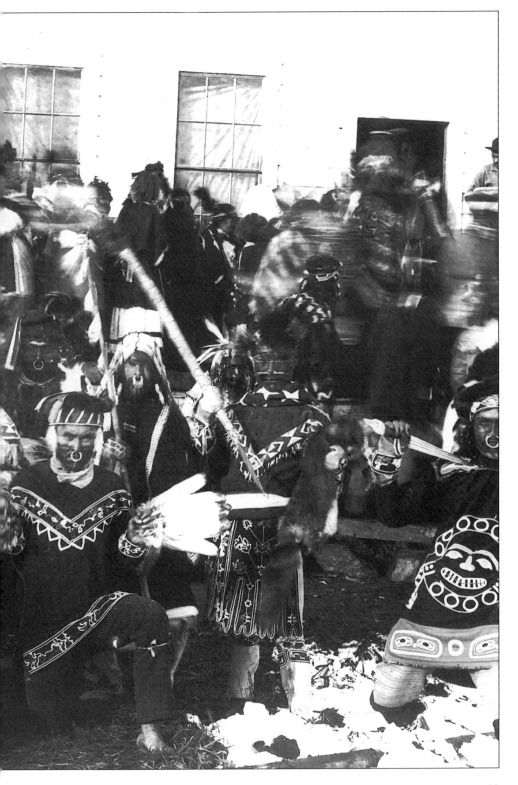

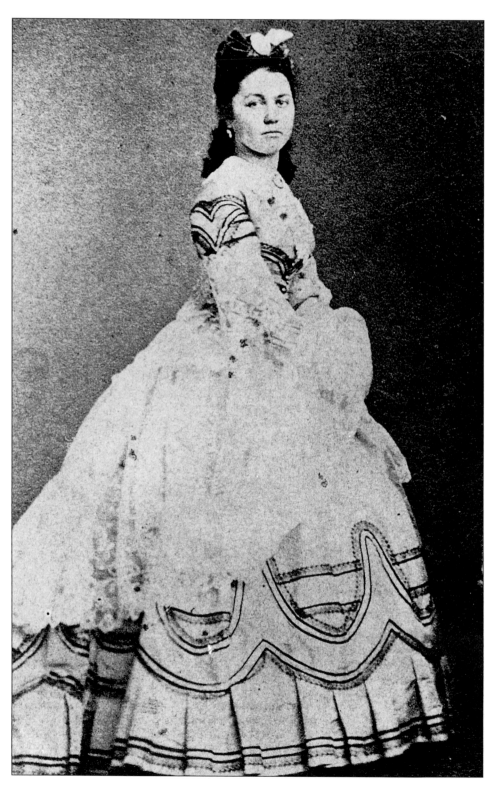

FOR GOD AND TSAR

The discovery of Southeast Alaska by Russia was a relatively recent event. The great Danish explorer Vitus Bering, in the service of the Tsar, sailed the north Pacific and in 1741 confirmed that the Alaskan coast was not part of the Asian continent. Bering's expeditions piqued interest in this region and soon other explorers developed a lucrative fur trade.

The first Russian settlements were on the Aleutian Islands. These communities were small and paved the way for more extensive development. The Russians were primarily interested in sea otter pelts which they could sell in China for astronomical sums. The rest of the world paid little attention to this trade until the late 1780s when its wealth was discovered by other nations. Within a few years, a rush for "soft gold" was on.

The Russians brought hundreds of Alutiiq natives from the Aleutian Islands to Southeast Alaska. The skillful Alutiiq hunted for the Russians as well as fighting for Russia against the Tlingits. Despite this, the Alutiiq were treated badly by the Russians and lived in a state of virtual slavery. Following the Battle of Sitka, Russia established a settlement. By 1808, the capital of Russian America had moved from Kodiak on the Aleutian Islands to Sitka.

In its heyday, Sitka was the largest city on the Pacific coast north of Cuzco, Peru. It was a busy community which prided itself on its Russian roots. The first chief manager of the Russian American company was Alexander Baranov. Baranov's primary goal was to ensure the success of the sea otter and fur seal trade. He also expanded Russian territory and the Russian Orthodox Church and surveyed a vast region. During this period, Russian posts were established as far south as California . For the most part, the living conditions in Sitka, as well as in other Russian communities, were poor. Food rations and cramped quarters were common.

Princess Maksoutoff, a Russian princess in Sitka, Alaska. Princess Maksoutoff was the wife of Prince Dmitri Maksoutoff, Chief Manager of Russian America, 1863-67.

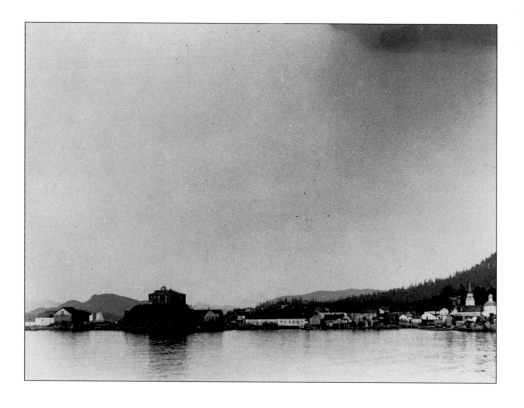

The architecture of Sitka was dominated by "Baranov's Castle" which was the center of operations for the Russian America company. From this promontory, the management of the Russian America Company could view the entire community. Other notable buildings included St. Michael's Cathedral and the Bishop's House. The Russian Orthodox church was a center for the community both as a place of worship and a place to gather.

Eventually the sea otter was hunted to the verge of extinction. The scarcity of pelts greatly impacted the economy of Russian America. At home, Russia was reeling in the aftermath of the Crimean War and other internal pressures. In desperation, in 1867 the Tsar sold Russian America to the U.S. for $7.2 million. The Tlingits opposed this sale as did many citizens of the U.S. and Alaska was dubbed "Seward's Folly" and "Walrussia."

Above: Scenic view of Sitka, Alaska. The building prominent on the rock is the "Castle" which served as a garrison for the community. Also visible is St. Michael's Cathedral on the far right. ca. 1888.

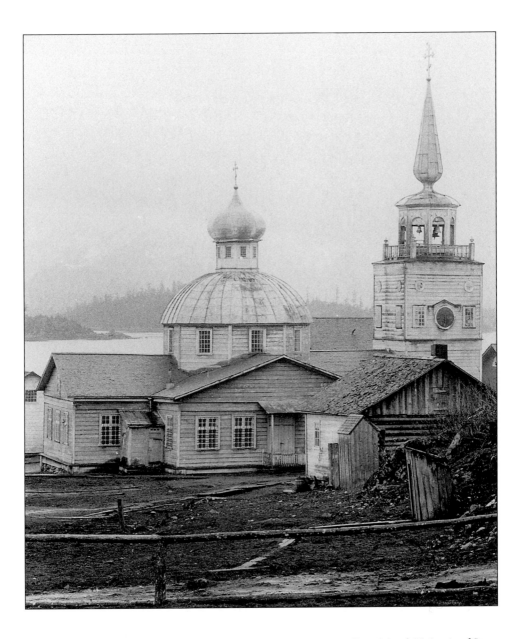

Above: St. Michael's Cathedral, Sitka, is a classic example of Russian architectural style. Built in the shape of a cross, St. Michael's was the first Russian Orthodox cathedral in North America. The cathedral was built under the direction of Bishop John Veniaminov, the learned inventor, writer and translator who lived in the Bishop's House. *Veniaminov served in the Aleutians before being assigned to Sitka.*

In January 1966, it was destroyed by fire. Fortunately, however, most of the icons, chandeliers and furnishings were saved. The cathedral was rebuilt and dedicated on St. Michael's Day, November 21, 1976.

Pages 34 and 35: Interior of St. Michael's Cathedral, showing several of the original icons. ca. 1888.

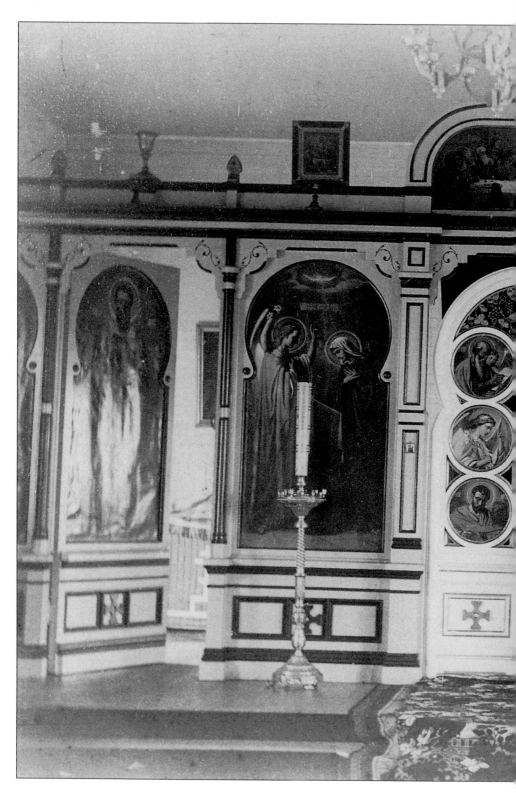

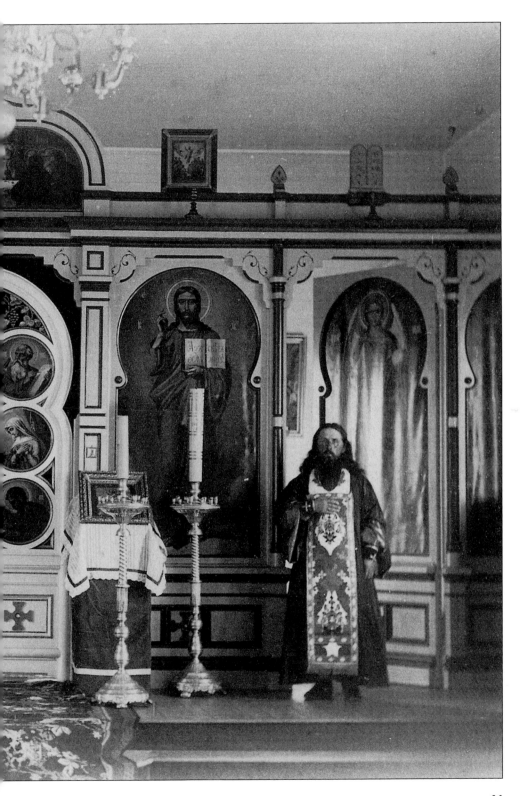

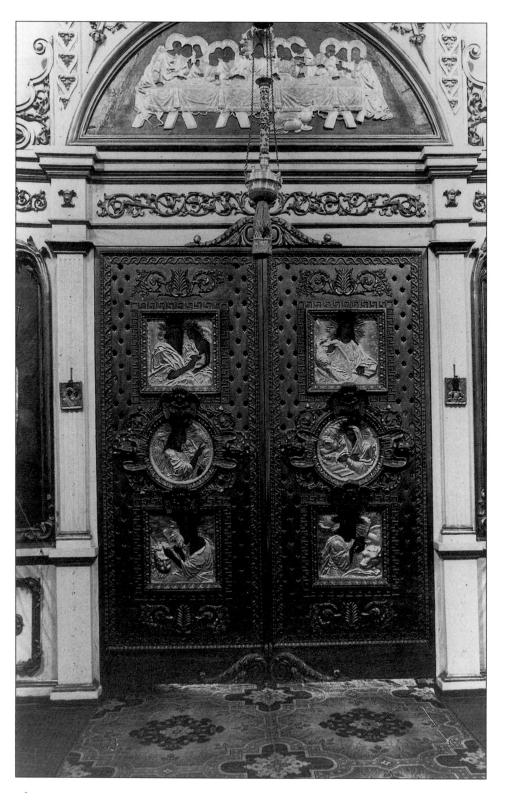

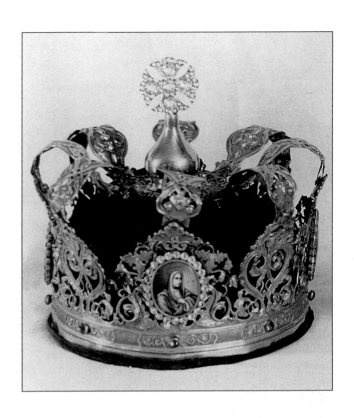

Opposite: The elaborate door to the altar of St. Michael's Cathedral, Sitka.

Right: Two Russian crowns in St. Michael's Cathedral, Sitka. Crowns are worn by the bride and groom - or held above their heads by attendants - at a traditional Orthodox wedding ceremony. The custom of wedding crowns continues in Alaska to this day in some small towns.

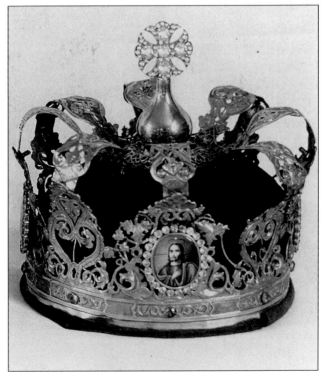

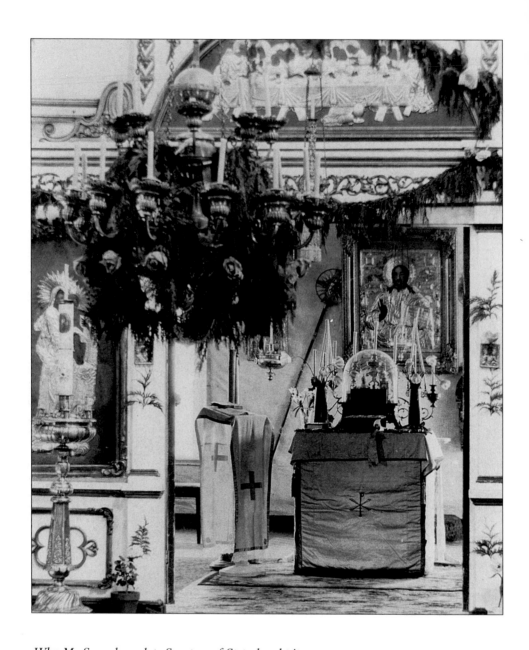

*Why, Mr. Seward, our late Secretary of State, bought it,
(Alaska) and Uncle Sam paid the Czar seven million two
hundred thousand dollars for it - a very considerable sum in
these hard times...suppose this amount of money to be placed
out at interest for fifty years at seven percent, will Alaska be
worth the result at the end of that time?*
Richard W. Meade, 1872

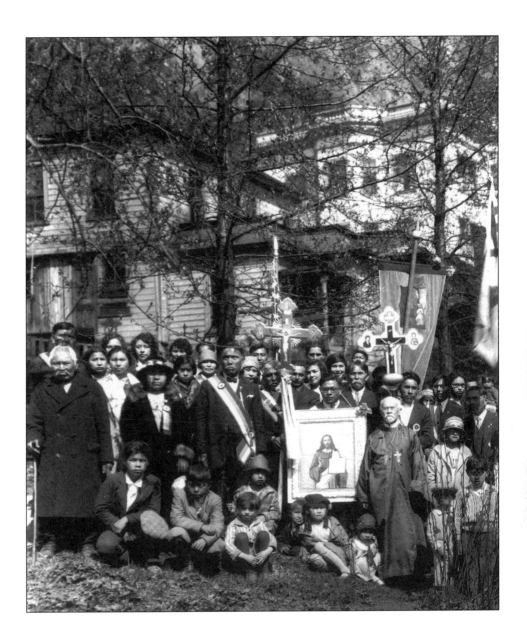

Opposite: Interior view of the altar in St. Michael's Cathedral, Sitka.

Above: Russian Orthodox Church members assemble in Juneau. Many natives were converted and the majority of parish members were either of Indian or Alutiiq ancestry. May 5, 1929.

The most valuable of all the furs is the sea-otter, which now brings from twenty-five to seventy-five dollars in Alaska. It is a beautifully soft purplish-black fur and very heavy, and in Russia is known as the "court fur," only to be worn by certain classes of the nobility. For any plebeian to wear this fur in Russia is an offence punished by fine, imprisonment, or exile to Siberia.
Richard W. Meade, 1871

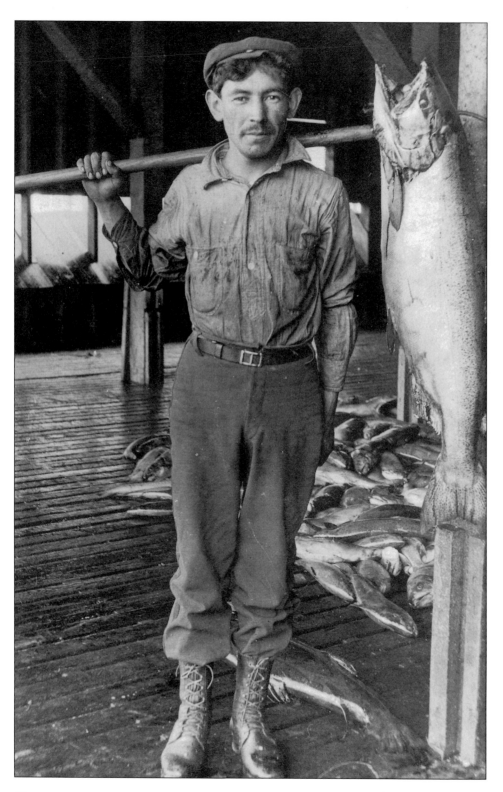

FISH

When the U.S. bought Alaska, the commercial fishery was virtually undeveloped. A decade later canneries were being built in numerous locations and Alaskan fish was being sold around the world. The abundance of salmon, halibut, herring, crab and shellfish became the driving force of the economy and led to the establishment of ports and communities up and down the Pacific coast.

The prize of the fishery has always been the abundant Alaskan salmon. The seasonal migration of salmon from the ocean to spawn in northern creeks and rivers allowed for relatively easy harvesting. For millennia, native people caught fish with gaffes, spears and hooks as well as with relatively small fish traps. Commercial fish traps were built as early as 1885. These traps frequently extended from the shore into the ocean for hundreds of yards and sometimes by more than half a mile. Fish traps were extremely successful and caught a staggering amount of fish each year. The fish traps corralled salmon into small enclosures which they could not escape. Fishers then had to haul these fish from their pens, a process called "brailing." Nearby salteries or canneries were able to process fish soon after taking them from the ocean.

Fish traps were efficient and relatively inexpensive to operate. Their use was always controversial as they were frequently owned by large non-Alaskan companies and could greatly impact the entire fishing industry. The crews required were few in number and often recruited from outside Alaska. Local independent fishers were marginalized and felt that there could be more employment by fishing from boats.

Man standing with a large salmon in the Alaska Packer Association cannery at Loring, near Ketchikan. Many salmon lie on the floor to be processed and canned. ca. 1909.

From the start, the issue of determining the sustainable number of fish which could be caught was an important question. The salmon fishery produced many jobs and millions in revenues, but also experienced cycles of busts and booms. A boom year frequently flooded the market and lowered salmon prices. When the fish stocks even-

tually crashed, canneries would close and devastate the local economy. These cycles were unhealthy for Alaska and there was a fear that the salmon, like the sea otter, could be driven into a state of virtual extinction. As a result, the first salmon hatchery was built in southeast Alaska in 1897. Other hatcheries, as well as fishing regulations to manage fish stocks, would soon follow. In 1957 fish traps were made illegal in Alaska.

During the early period of the fishery it was common practice for ships to sail to China to hire seasonal workers and buy empty tin cans. Chinese workers spent the summer at canneries processing salmon. Once the fish was canned the ship would return the workers to China and sell the canned fish which was crammed in their holds. This was a lucrative enterprise which made cannery owners wealthy.

Fishing for halibut and other deep water fish was often more challenging than catching salmon. Small schooners would release small two-man dories. The fishermen would row to fishing grounds and drop long hemp fishing lines with many baited hooks. Since halibut usually winter in water more than three hundred feet deep, handling these lines was difficult. Sometimes a few halibut would be on a single line which meant that the fisher had to pull hundreds of pounds of fish, a challenging task. Storms, fog and the unpredictable nature of this type of fishing meant hand fishing was dangerous work.

Net fishing at the turn of the century allowed a larger commercial industry to be established. Initially sailboats dragged these nets, but by 1910 gasoline-powered ships were being introduced in Southeast Alaska. These innovations were followed by cold storage plants and eventually by shellfish processors in the late 1930s.

A view looking down from the mast to the deck of the sailing ship "Star of Scotland." This ship frequently traveled from San Francisco to Loring, Alaska. Loring, near Ketchikan, was a major cannery and processed tons of salmon annually. ca. 1909.

The harvest of crab allowed the fishing industry to broaden. Crabs were either canned or packed in ice and shipped live. The crab fishery relied on traps or "crab pots" to be dropped on long lines and left on the bottom. Fishers had to check their traps frequently and this type of fishing became popular.

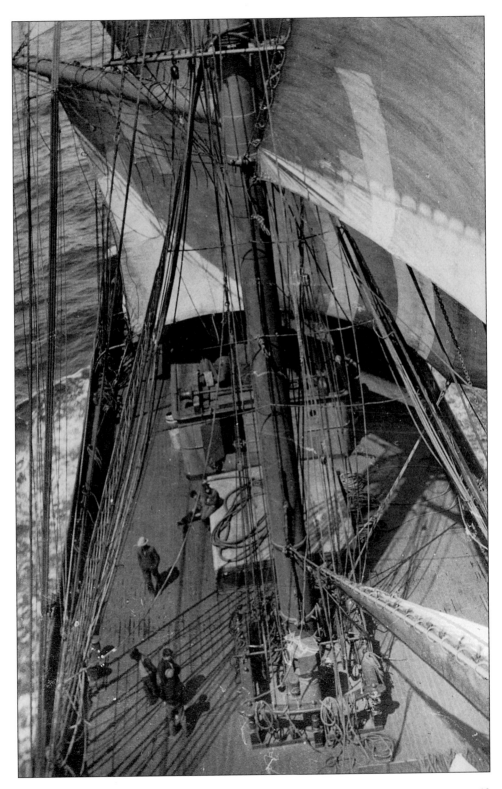

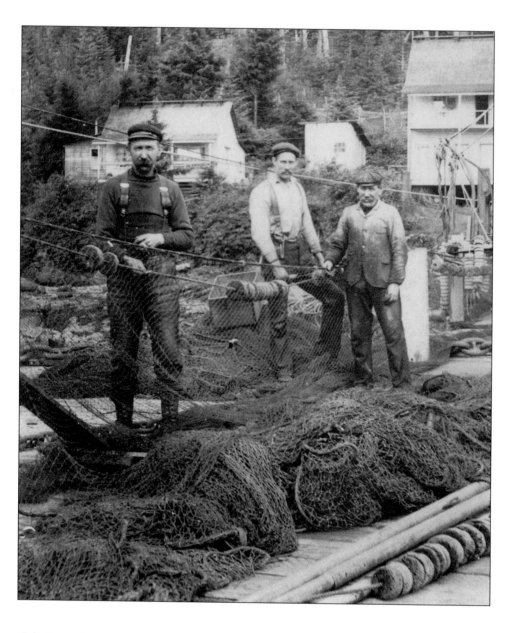

Of salmon there are myriads. Every fresh-water stream is filled with them during the season, which commences in the latter part of June...The first "run" has the choice fish.
Richard Meade, 1872

Above: A crew of three mending the web for a floating fish trap at the Alaska Packer Association cannery at Loring. August 9, 1909.

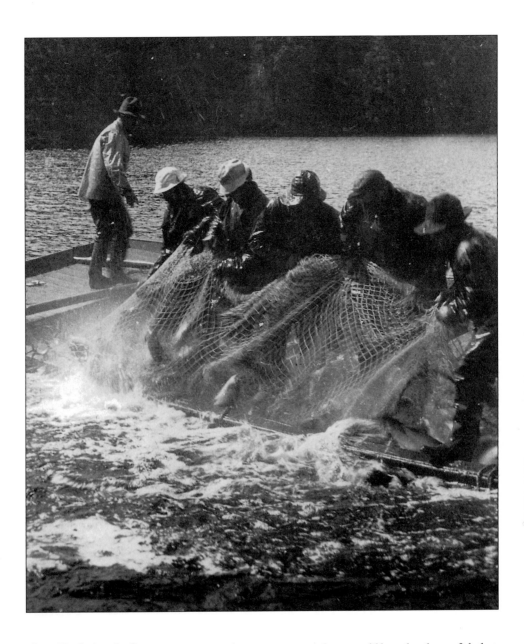

Above: Hand-seiners hauling a net full of salmon into a cannery boat. These fish were destined for the Alaska Packer Association cannery at Loring, Alaska. Summer 1908.

The sculpin is not esteemed as an edible or handsome fish, but he is very numerous and a great scavenger. He looks very much like a rutabaga turnip covered with warts with a slit entirely across the big end for a mouth. He is so ugly that old fishermen torture him just for his ugliness.
Charles Hallock, The Outing Magazine, 1908

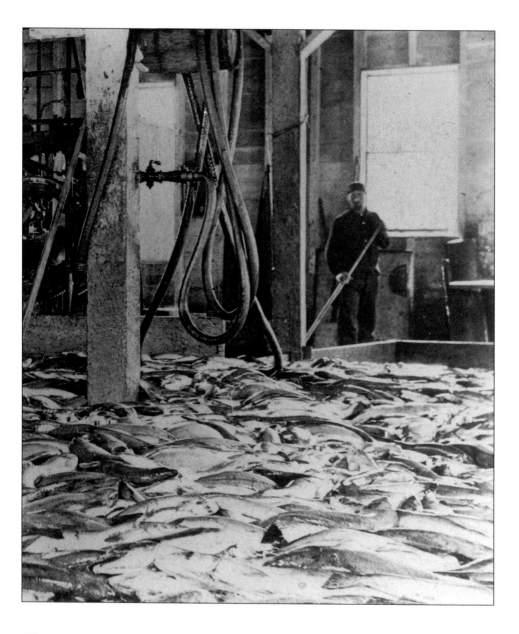

Their numbers are beyond conception. Often-times there seem to be more fish than water in the rapid portions of the streams...Surely in no part of the world may one's daily bread be more easily obtained.
John Muir, 1897

Above and Opposite: Salmon strewn across the floor of the Alaska Packer Association cannery at Loring. ca. 1909.

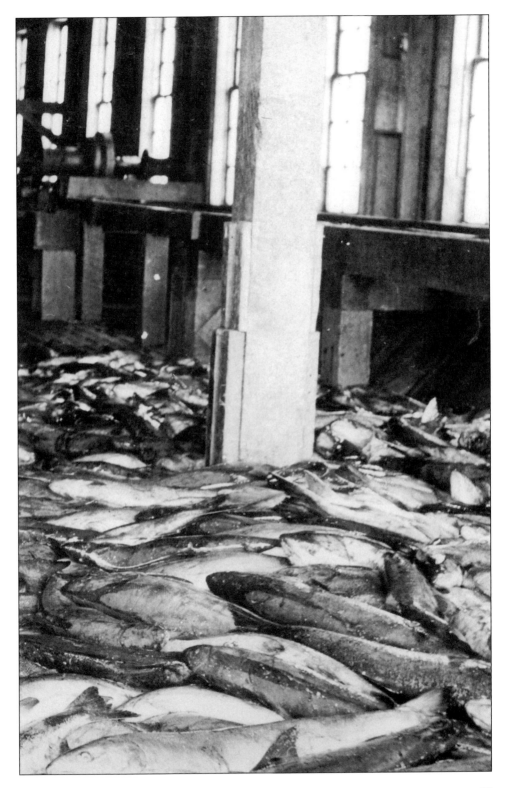

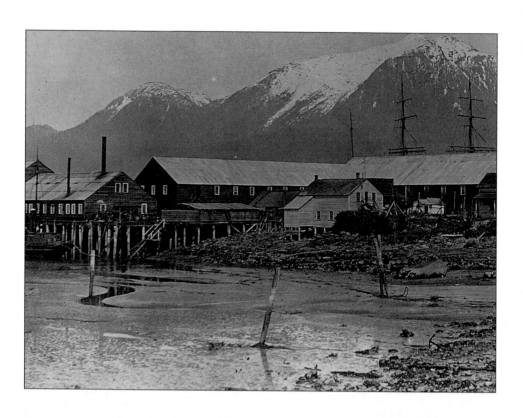

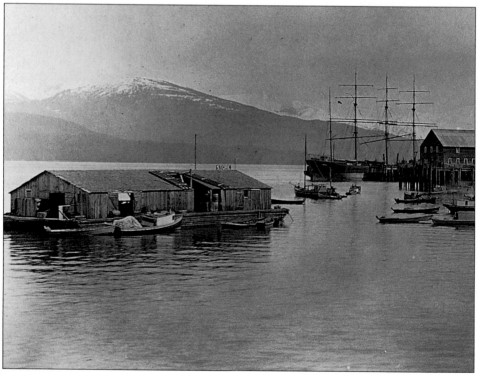

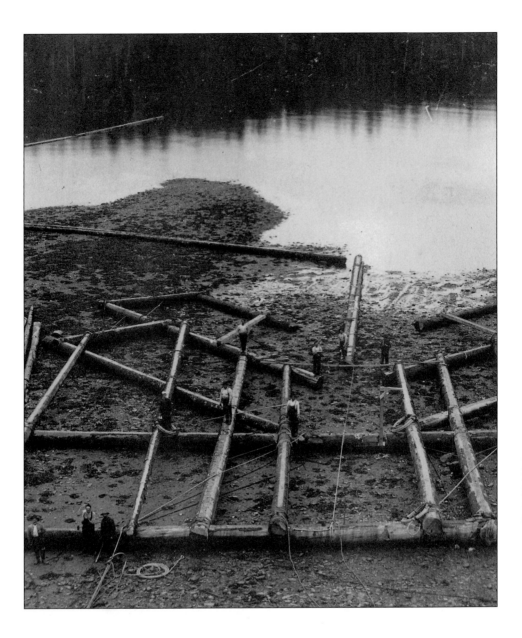

Opposite: Alaska Packer Association cannery near Wrangell. ca. 1911.

Above: A crew from the Alaska Packer Association cannery at Loring. They are constructing a floating fish trap on the beach at low tide. The frame is built from massive logs and is ready for the webbing to be attached. ca. 1909.

The first sight of a salmon-cannery is a new experience, - the
gleaming fish heaped upon the floor, Indian canoes unloading
their fresh "catch" at the door, Chinamen wielding the knife
with a celerity as machine-like as the whirring wheels. It was
a thirty-pound salmon five minutes ago; now it is a row of
deftly packed cans that go spinning along a tramway to the
soldering. A can is covered, is whirling on a spindle against a
hot soldering iron, is working its way onward, by an endless
chain, under jets of water that wash it as it goes, - and in a
twinkling it is in the boiling bath. Night after night the
steamer-loading goes on: the first wonder is, how the world can
consume so much salmon, the second, how long Alaska can
furnish it; for surely no waters can long supply such marvel-
lous quantities of fish.
Lucy M. Washburn, 1894

Above: A view of a skiff in front of
what is likely Yes Bay, north of
Ketchikan. A steamship, houses
and buildings can be seen along the
shoreline.

Opposite: Four workers at the
Alaska Packer Association cannery
at Loring. On the floor behind
them, salmon await processing.
August 20, 1909.

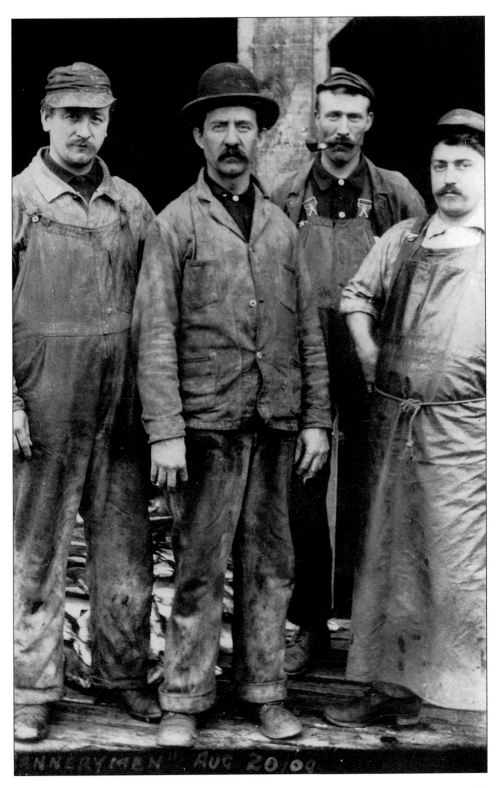

"CANNERYMEN" AUG 20/00

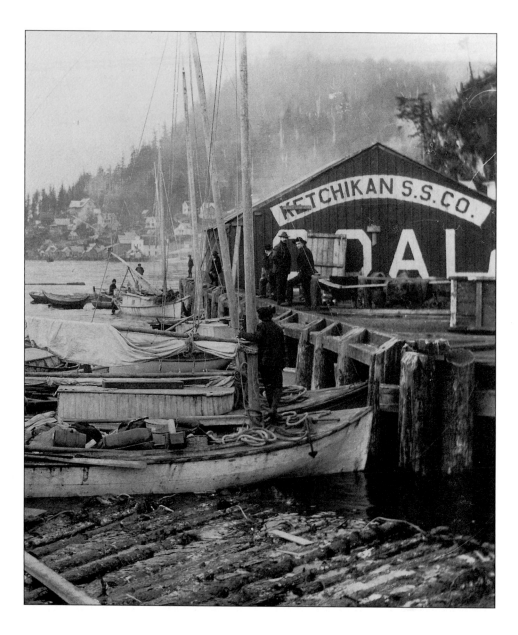

Occasionally there are nights when the sea is luminous with phosphoresence, and all the crests of the flowing waves break in cascades of silver and gold; every dip of the oar stirs up pyrotechnics of sparks and glistening stars, and the revolving wheels of the steamer throw off streams of evanescent light. The lustrous glow piles up in front of the prow and trails off in the receding wake.
Charles Hallock, The Outing Magazine, 1908

Above: Ketchikan waterfront with small sailboats in front of the Ketchikan Steam Ship Company dock. ca.1910.

Above: A fishing smack in the Lynn Canal near Haines.

We had scarcely furled the sails, when the wind shifting to the south-east, the threatened storm from that quarter, began to blow, and continued with increasing violence during the whole night; we had, however, very providentially reached an anchorage that completely sheltered us from its fury, and most probably from imminent danger, if not from total destruction. Grateful for such an asylum, I named it Port Protection.
Captain George Vancouver, 1792

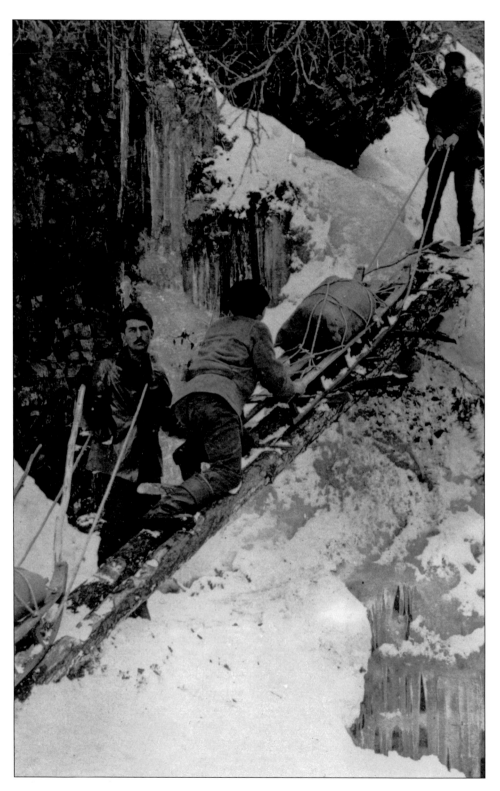

BONANZA!

When the small steamship *Excelsior* docked in San Francisco in July 1897, the world was watching. Aboard this vessel were millionaires who had been penniless men only months before. As these scruffy miners swaggered down the gangplank carrying jars, satchels and cases filled with Klondike gold, more than five thousand people crowded the docks and cheered. A few days later the steamship *Portland* landed at Seattle with sixty-eight more successful miners and almost a ton of gold. The news of the find grabbed newspaper headlines and was on everyone's lips.

Within days, thousands flocked to west coast towns from San Francisco to Vancouver trying to book passage north. The fact that the Klondike was more than fifteen hundred miles away and over a precipitous mountain pass would not deter many. Gold fever had grasped the nation, and everyone wanted the chance to try their luck in the new frontier.

The wealthy booked passage on steamships to the port of St. Michael, at the mouth of the Yukon River on the Bering Sea. Paddlewheel steamships then carried them up the Yukon River to Dawson City.

Less well-heeled stampeders faced one of the most arduous treks imaginable. They traveled up the coast in overcrowded and often decrepit ships. They spent the winter ferrying supplies over the cold and dangerous Chilkoot and White Passes, then built rickety boats and navigated the lakes and rapids of the Yukon River. Whatever their route, most stampeders arrived in Dawson City in the spring and summer of 1898. Dawson City's meager population swelled to more than 40,000. In its heyday, Dawson City was the largest city west of Winnipeg and north of San Francisco. The town of Skagway flourished throughout the gold rush as a supply route for the Klondike. The construction of the White Pass and Yukon Route Railway began in haste on May 28, 1898 and would ensure future prosperity.

Stampeders hauling sleds up "Jacob's Ladder," in a canyon on the Chilkoot Trail. ca. 1898.

The large number of idle stampeders in Skagway and Dyea provided an eager workforce for the railway. Laborers were paid three dollars a day, and with overtime some earned more than a hundred dollars a month. The steep granite mountain sides were perhaps the greatest obstacle to construction. In total 450 tons of explosives were used to blast a path to the summit. Entire mountain sides were shattered, and valleys echoed with the thunder of black powder. In addition to blasting through the Pass, enormous bridges and tunnels had to be built. The most impressive was the steel cantilever bridge which spanned a deep mountain valley and was the tallest bridge in the world when it was built.

On July 29, 1900 the "Golden Spike" was driven and a 110-mile link between Skagway and Whitehorse was complete. In total, the railway had cost ten million dollars and had taken 26 months to complete. Dyea became a ghost town almost overnight.

During the first couple of years of the Gold Rush, the city of Skagway was the type of frontier town seen in western movies. It had makeshift buildings with false fronts, gambling halls, saloons, dance halls and bandits. The most notorious outlaw was Jefferson "Soapy" Smith. His gang of crooks were experienced con men and thieves, many of whom were veterans of other gold rushes. Skagway was an outlaw's haven and Soapy's gang conned, cheated and stole from stampeders at will. Eventually a vigilante group formed to put an end to Soapy's empire. A gunfight followed, leaving Soapy dead, and a short time later his assailant Frank Reid also died.

The Klondike Gold Rush brought thousands of people to Southeast Alaska. The rush not only put the region on the map but also left an indelible mark of frontierism and entrepreneurship. A pattern of development had been established which meant great changes for Indians, settlers and the natural environment. These changes had their benefits and costs. Southeast Alaska would never be the same.

Stampeders amid mountains of supplies landed near the mouth of the Taiya River near Dyea, Alaska. The North West Mounted Police required each stampeder to be equipped with a year's supplies (1500 to 2000 pounds) when crossing the border into Canada. ca. 1898.

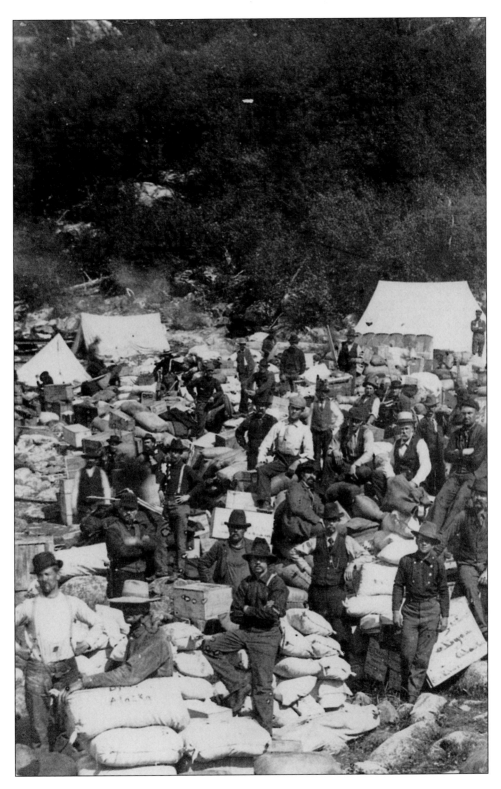

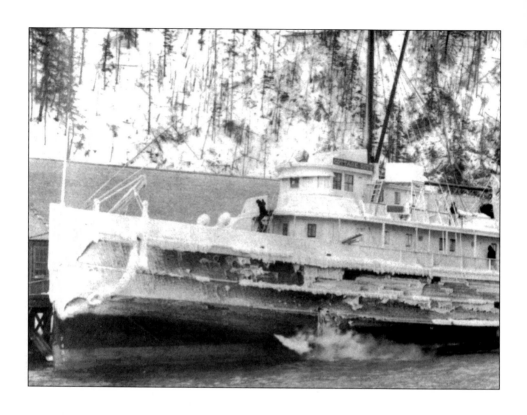

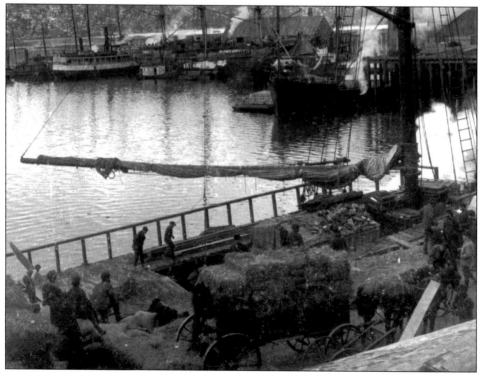

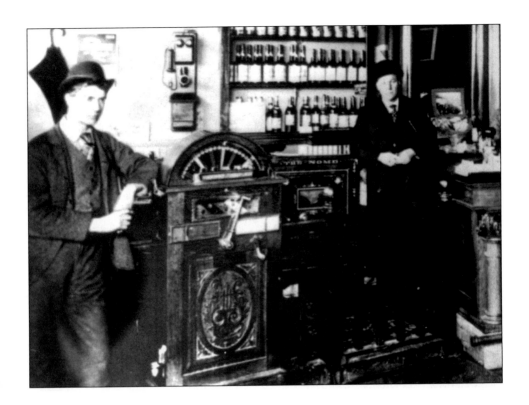

Opposite Top: It was common for ships to arrive in Skagway and Dyea during the winter encrusted in snow and ice. In the early days of the Gold Rush there wasn't even a wharf leading to the harbors which meant scows had to ferry supplies and passengers to shore.

Opposite Bottom: Unloading supplies in the busy Skagway harbor.

Above: The Nome Saloon in Skagway had an elaborate bar and a wide varity of spirits.

Pages 60 and 61: Members of Soapy Smith's gang (Smith is in the center with a beard and hat.) Smith was a legendary outlaw who brutally robbed and cheated many stampeders. After Smith was killed in a shoot-out with Frank Reid in 1898, his gang was forced to leave Skagway.

...whole saloonfuls of men would be asked up to drink, at half a dollar a drink. Sometimes orders were given to call in the town, and then the bartender would go out into the street and call everybody in, and all would have to drink. Whenever one of the new "millionaires" was backward in treating, which was not often, the crowd - always a good natured one - would pick him up by the legs and arms and swing him like a battering-ram against the side of the house until he cried out "enough!"
Tappan Adney, Journalist, 1899

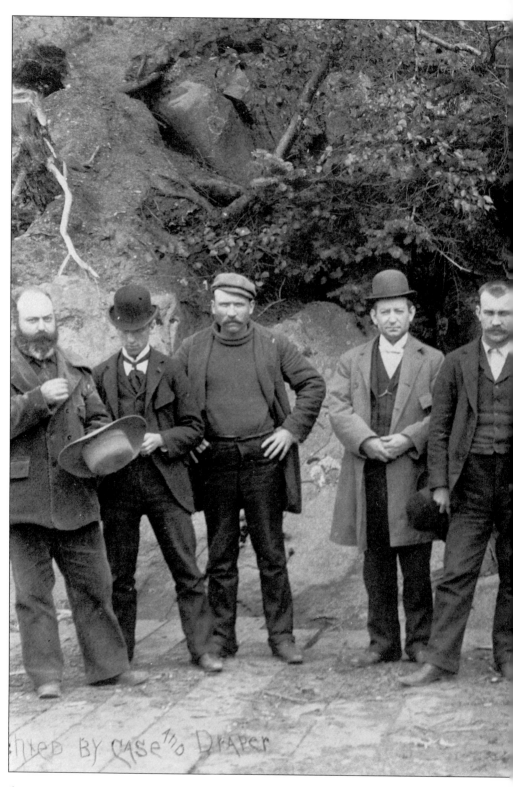

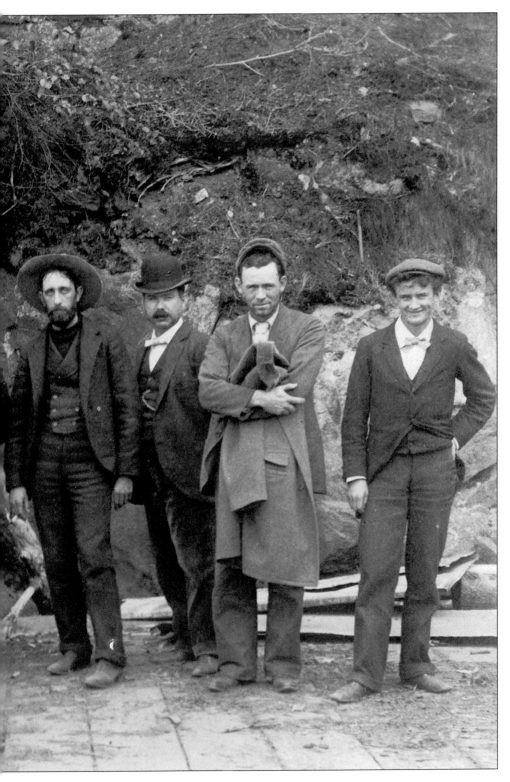

Above and Opposite: Thousands of horses were brought to Alaska during the Klondike Gold Rush. Many stampeders were inexperienced with horses, and as a result many horses died from starvation, injury and exhaustion. The White Pass Trail was a narrow path that followed the Skagway River for much of its course. This path was steep and had numerous sink holes where horses easily broke ankles or were impaled on stumps. Gold fever drove stampeders to abuse their half-starved horses in the most horrible manner. When the horses dropped from exhaustion or broken limbs, the line of miners and pack animals walked over them until the bodies became part of the trail. For this reason the White Pass became known as the trail of "Dead Horses." More than 3,000 horses died during the first year of the Gold Rush.

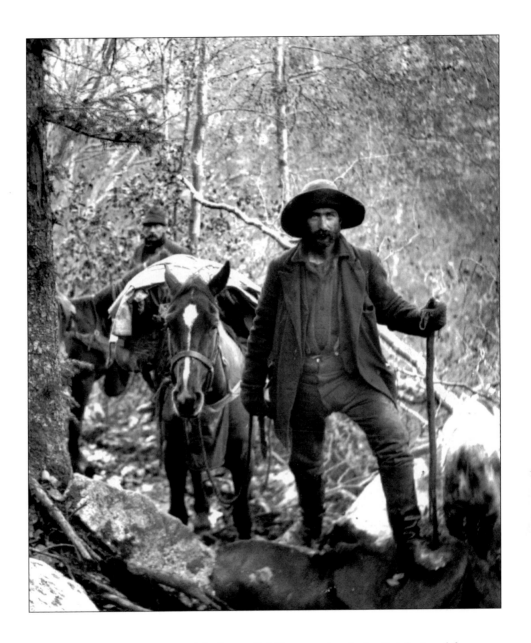

The horses died like mosquitos in the first frost, and from Skagway to Bennett they rotted in heaps.
Jack London

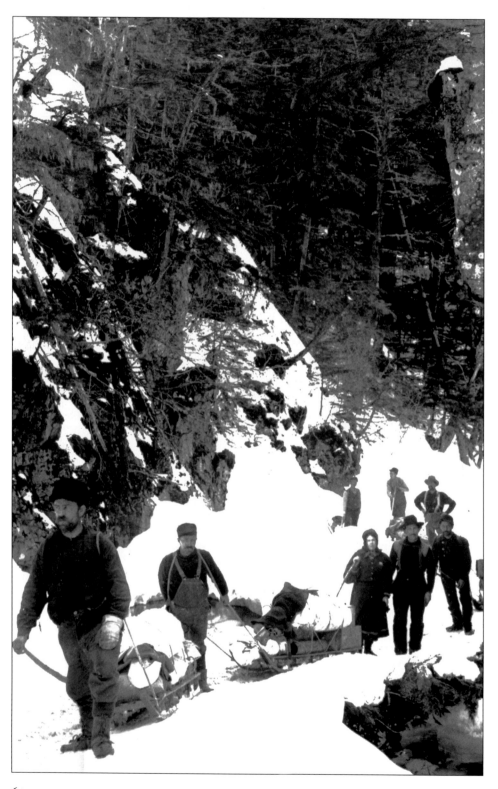

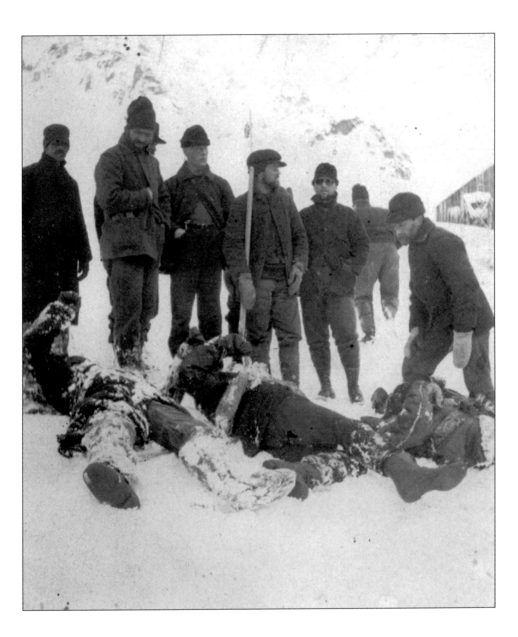

Opposite: Stampeders hauling supply sleds over the snow-covered Chilkoot Trail. Many stampeders formed small "pack trains" to cope with the rigors of the Chilkoot. The trail exacted an incredible psychological and emotional toll on the stampeders. Many would later recount that it was the most challenging endeavor of their lives.

Above: On April 3, 1898, a massive avalanche swept from a slope 2,500 feet above the Chilkoot Trail. Within seconds the trail was buried under tons of snow, ice, rock and debris. Hundreds raced to dig for survivors. In total more than 70 men perished. Tlingit packers had warned of the risk of avalanche for several days prior to the accident, but few acted on this advice.

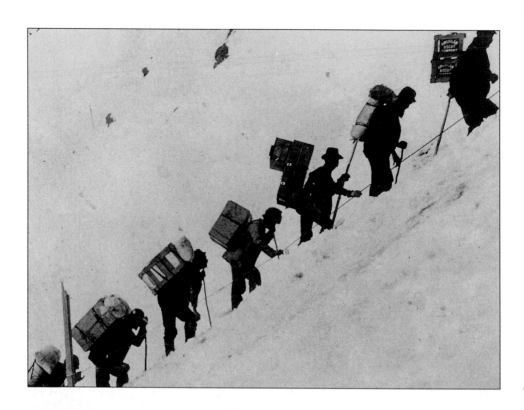

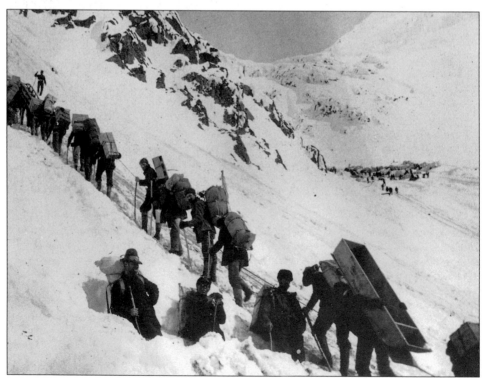

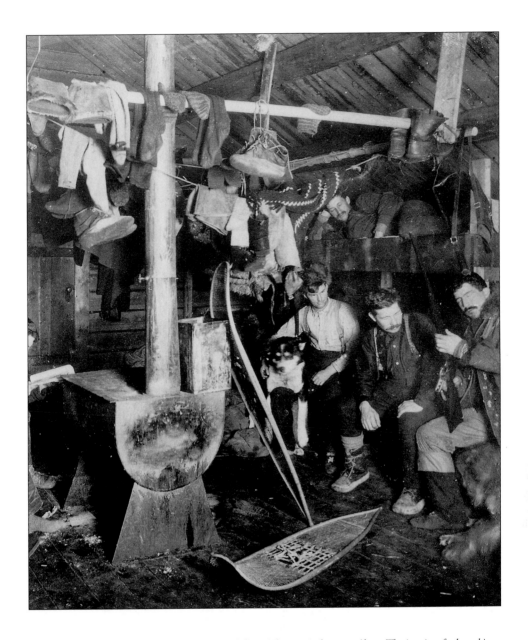

Opposite Top and Bottom: Stampeders ascending the "Golden Stair" to the summit of the Chilkoot Pass. In most seasons, snow slopes and steep ice cover this thirty-degree slope to the summit. The Golden Stair had fifteen hundred steps cut into it, with a single icy rope to clutch.

Each stampeder carried almost a ton of provisions and supplies over the Chilkoot. This required each person to make an average of twenty to thirty trips along this trail. The wealthy could hire Indian packers or later in the rush use the tramway to carry supplies. Most stampeders simply put their heads down and grunted their boxes, bags and satchels over the pass. Many took several months to complete the ascent of the Chilkoot.

Above: The interior of a log cabin. Stampeders gather around the woodstove with clothing drying from the ceiling.

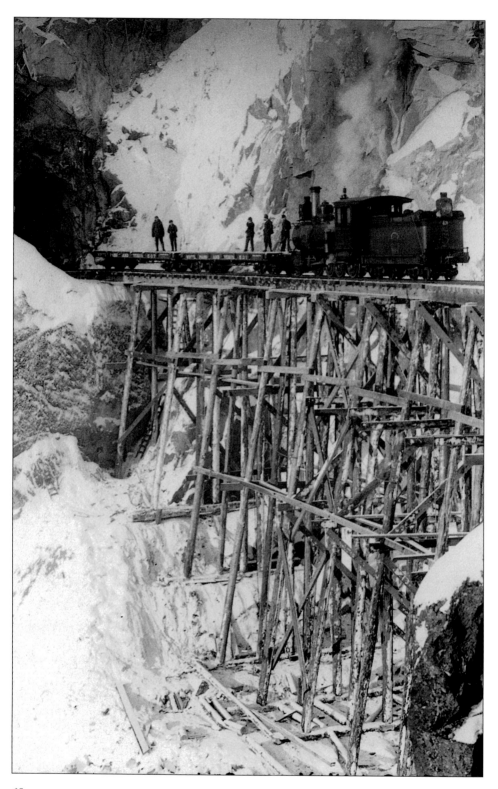

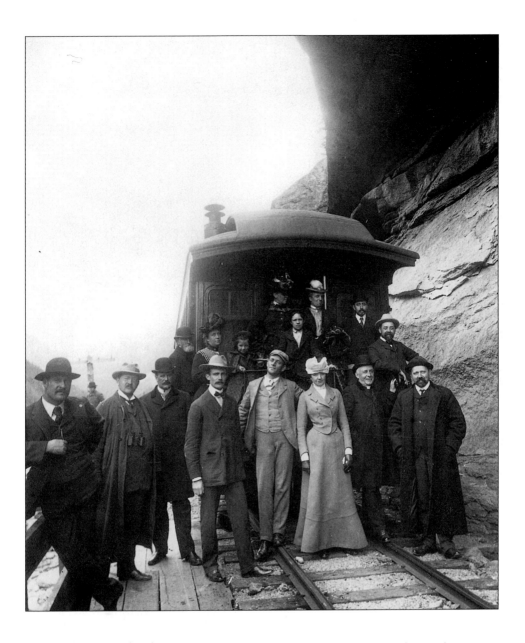

Opposite: A train stopped on the trestle bridge in front of the tunnel on the White Pass and Yukon Route Railway.

Above: Passengers standing in front of a train parked under the hanging rock at Clifton, Alaska. ca. 1901.

A little more than one year ago a company began what was then considered an impossible task, that of constructing a railroad from Skagway to the summit of White Pass. But where energy and money combine, defeat is unknown.... Yesterday the road was completed to Bennett, making it possible for travelers from any part of the United States to reach Dawson City on one continuous journey where all the comforts of life may be enjoyed.
The Daily Alaskan, July 1899

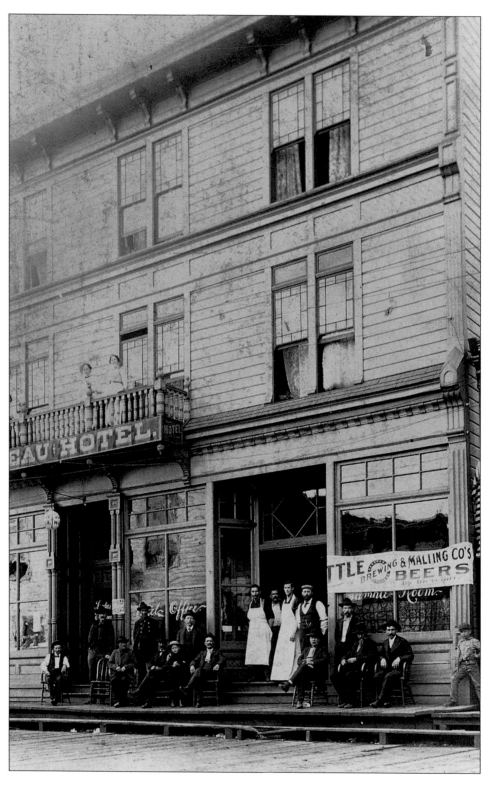

TOWNS EMERGE

Other than Sitka, Russia had little interest in establishing towns and cities in Southeast Alaska. After the purchase of Alaska, the U.S. quickly developed one of the richest fisheries in the world. This economy allowed for an infrastructure and other enterprises to develop. The Klondike Gold Rush, as well as other gold rushes, put the region on the map and encouraged investment in a range of activities. Most of the towns of Southeast Alaska were fishing towns, and to a lesser extent, dependent on forestry.

Ketchikan, Wrangell, Petersburg and Haines, as well as other towns, prospered from fishing, and a large fishing fleet quickly matured. Wharves, salteries and canneries serviced the world taste for Alaskan fish. Saloons, restaurants and hotels met the many social needs of the fishers. Red light districts such as Fleet Street in Ketchikan became infamous for the comfort they provided to men, in many cases hundreds of miles from home.

Commercial logging was initiated to provide boxes for shipping fish and fish traps, warehouses and wharves. The emerging towns of Southeast Alaska created a local market for lumber and a variety of wood products such as shakes for roofing. The loggers used axes and hand saws to cut trees near the water's edge. Ships pulled these logs to sawmills where they were cut into boards. Eventually an export market for Alaskan wood would be created.

Skagway and Dyea were built during the Klondike Gold Rush as break-of-bulk points between the Pacific and the Coast range. The White Pass and Yukon Route Railway ensured Skagway's role as a corridor for supplies headed for the interior. Mines in the Yukon would also use the railway to carry gold as well as various ores headed for the south. Dyea suffered a less prosperous fate and was deserted within a couple years of the Gold Rush. Little remains of Dyea today.

Smaller towns like Klinquan, Hoonah and Kasaan were founded as Indian communities. These towns blended

The Juneau Hotel which was located on Second Street was a three-story building which was prominent in the early days of Juneau.

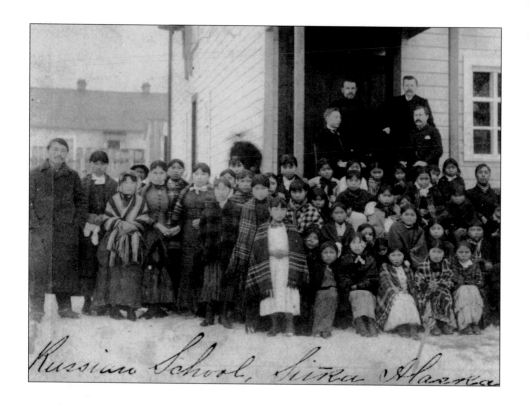

Russian School, Sitka Alaska

traditional lifestyles with commercial fishing and logging. Historically these communities had existed for thousands of years. After the Russians sold Alaska to the U.S. rapid change followed. Mission schools and restrictive laws directed towards Indians had great impacts on these communities. Perhaps the most damaging was the laws prohibiting Potlatch ceremonies. Tlingit arts and dancing fell into decline and it would take seventy years for these laws to be repealed.

The towns of Southeast Alaska were united by ferries and ships which carried people and supplies. Air travel would make things easier, but water travel remained the predominant means of transportation.

Above: Russia established schools for Indians which was a tradition followed by the U.S. Many schools were operated by missions and churches. These schools had a great impact on Indians and are considered a cause for many challenges faced today by Indians.

Opposite: Front of a small building housing Ketchikan's newspaper "Mining Journal." Governor Alfred P. Swineford of Alaska is on the porch wearing a hat. Governor Swineford was appointed by President Cleveland and served from May 7, 1885-April 20, 1889.

Pages 74 and 75: Front Street Ketchikan looking north from Hotel Revilla, just past the corner of Mission Street. October 5, 1905.

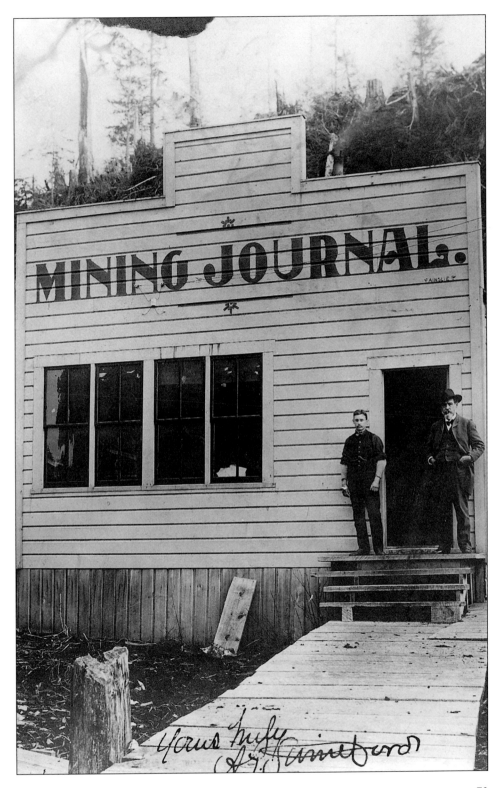

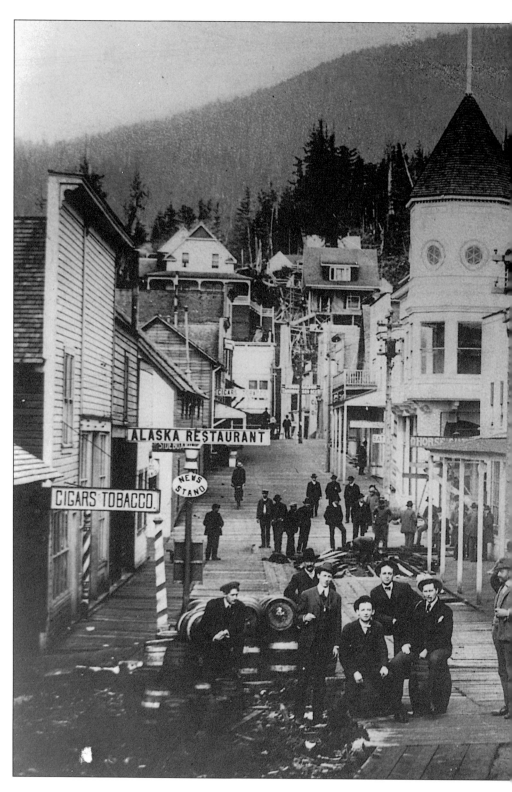

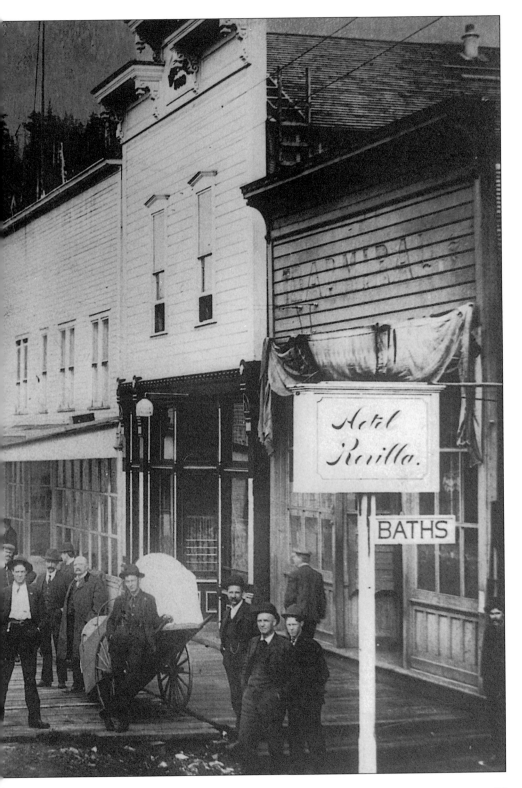

Hotel Revilla

BATHS

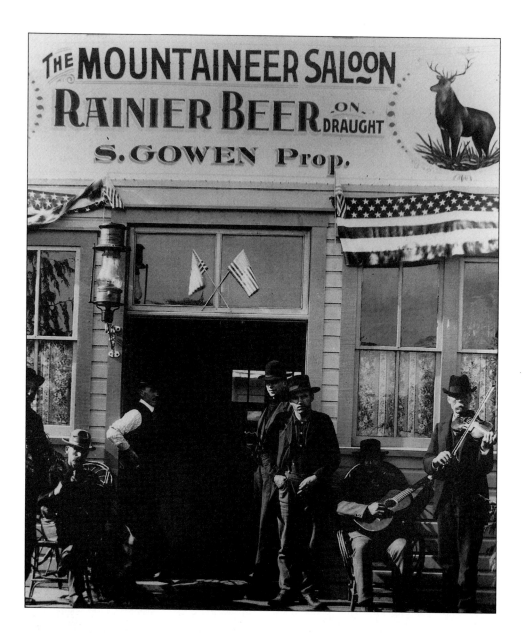

Above: Musicians on the Fourth of July in front of the Mountaineer Saloon, Ketchikan. ca. 1910.

Opposite Top: A view of the Ketchikan waterfront. The construction of Main Street is incomplete and the area on Courthouse Hill has not been developed. ca. 1902.

Opposite Bottom: The gas-powered "Walrus" steaming past the Ketchikan Steam Ship Company and coal dock. ca. 1904.

Pages 78 and 79: View of Wrangell with Chief Shakes' totem and its whale hat. Mount Dewey rises in the backgound.

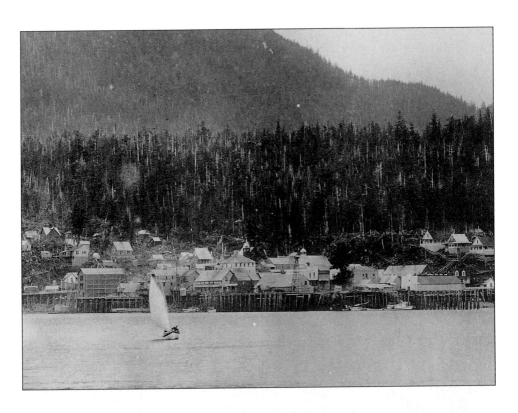

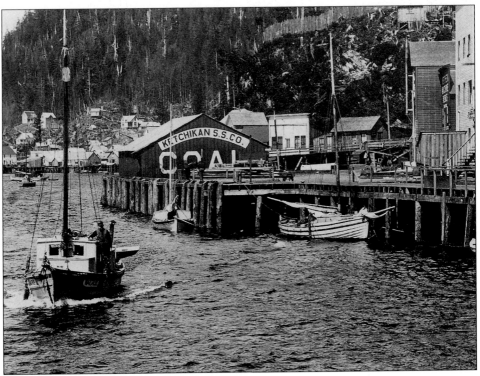

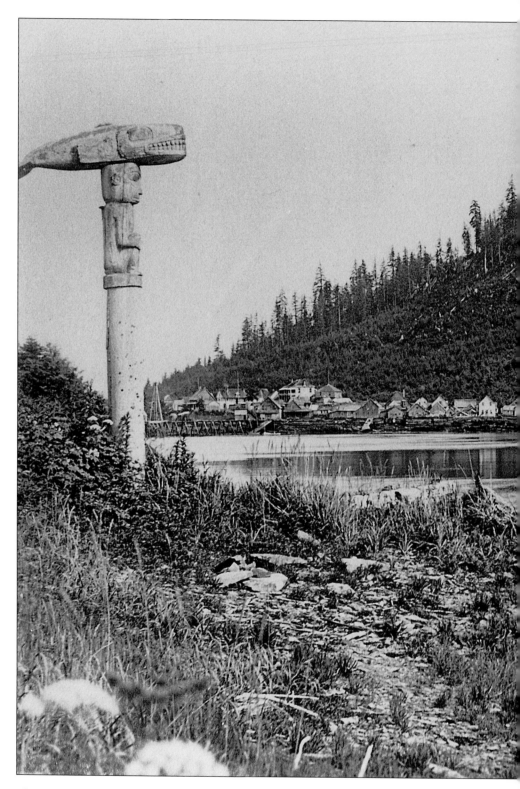

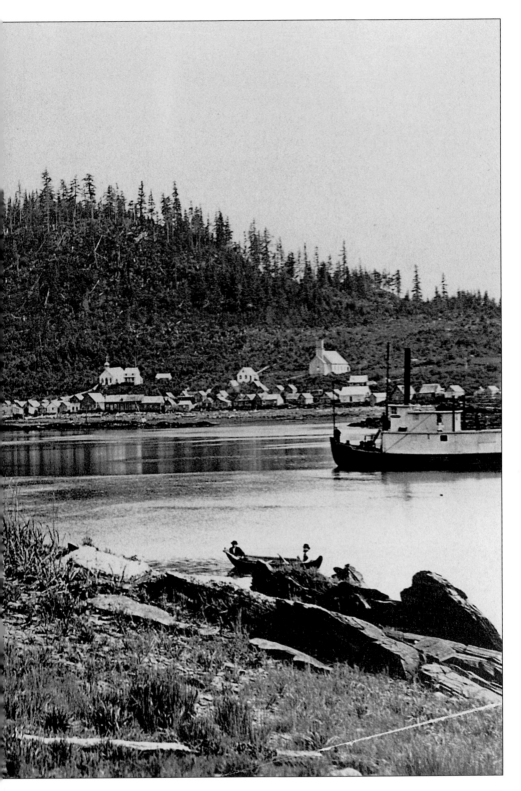

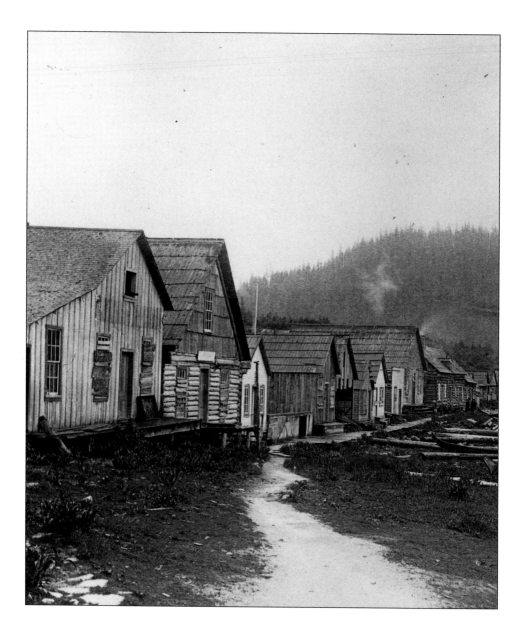

The Wrangell village was a rough place. No mining hamlet in the placer gulches of California, nor any backwoods village I ever saw, approached it in picturesque, devil-may-care abandon. It was a lawless draggle of wooden huts and houses, built in crooked lines, wrangling around the boggy shore of the island for a mile or so.... Stumps and logs, like precious monuments, adorned its two streets...

John Muir, ca. 1880

Above: Wooden homes along the Wrangell waterfront at low tide. The demand for wood for construction created work for small logging and milling operations. ca. 1887.

Opposite: Wrangell and harbor as seen from the mountain behind the town. December 30, 1913.

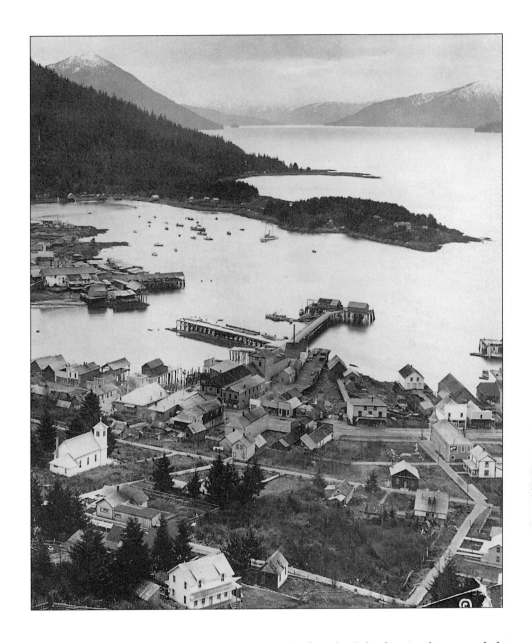

*Twelve hundred miles from the Columbia river bar we touched
at Fort Wrangell, a filthy little town at the mouth of the
Stickeen, where the miners from the gold-diggings up the
Stickeen River spend the winter in squalor and drunkeness.
The Century Magazine, July 1882*

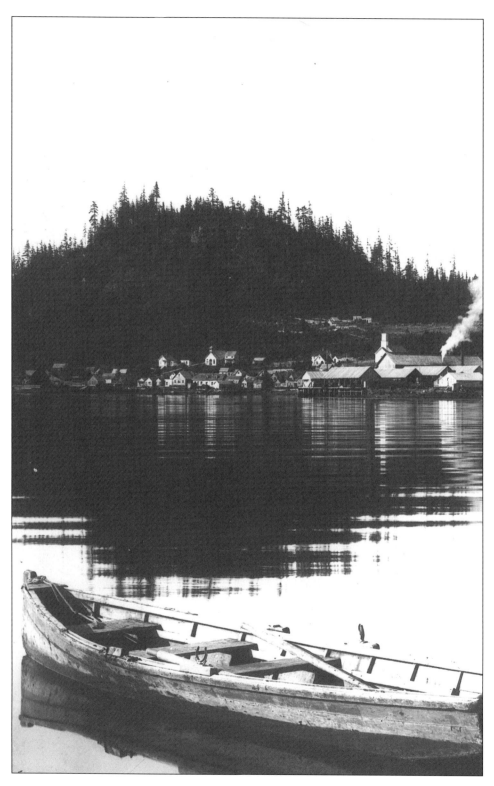

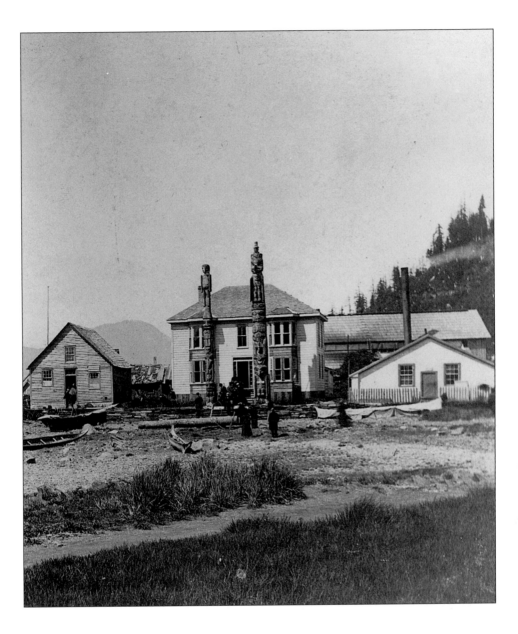

Opposite: A dory in front of Wrangell. Wrangell is the only town in Alaska to have been ruled by four nations: the Tlingit, Russians, British and the United States.

Above: Two totem poles can be seen in front of the Kadishan house in Wrangell. Kadishan, a subchief of the Stikeen Tlingit, accompanied naturalist John Muir on a canoe voyage in this area in November, 1879.

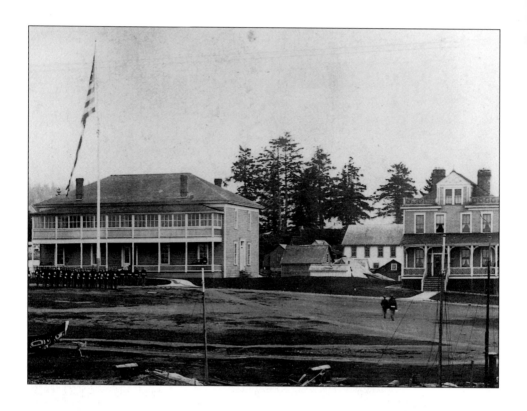

As we entered the harbor of Sitka from the sea the general appearance of the place was tropical. The snowy cone of Edgecumbe first appeared, then the sharp peak of Vostovia - a triangular patch of white against the sky. Everywhere below the snow-line the mountains were green with luxuriant growth. The harbor was protected against the sea by a curved line of reefs, on which grew firs and pines and cedars, with bare trunks and tufts of branches, making them look not unlike palms. The warm, moist atmosphere curtained all the middle distance with a film of blue, and, in the foreground, a fleet of very graceful canoes, filled with naked or half-naked Indians, completed the illusion.
The Century Magazine, July 1882

Above: The scenic Sitka waterfront with two boats and the Marine Corps barracks.

Opposite: Sitka Indian village.

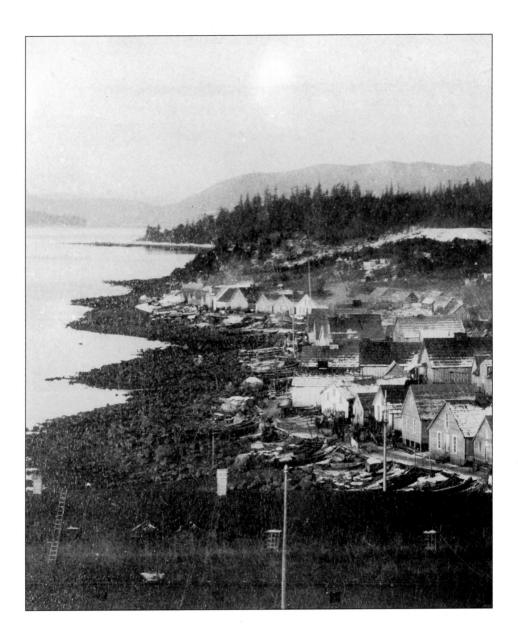

There are but two seasons in Sitka - the long rainy season
and the short rainy season. In the long rainy season it rains
nine months of the year; in the short rainy season, the other
three! Rain, rain, rain!
Richard W. Meade, 1871

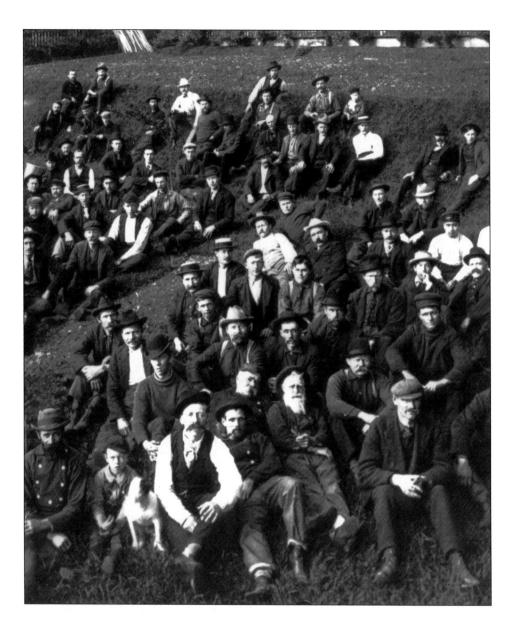

Above: A group of Petersburg Cannery employees posing for a photograph on a landscaped and fenced yard. ca. 1902.

Opposite Top: Petersburg shipyard employees standing inside a shed where scows and various types of boats were built. ca. 1902.

Opposite Bottom: Petersburg shipyard employees standing in front of sheds with ramps leading down to the water. ca. 1902.

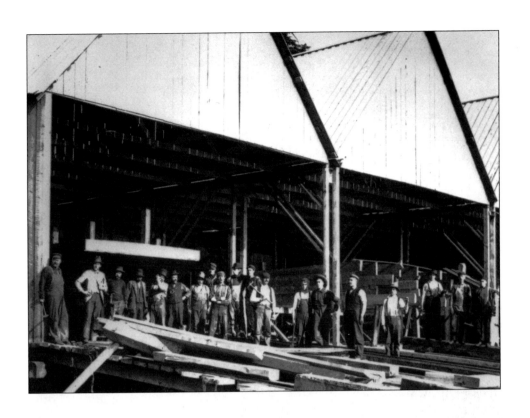

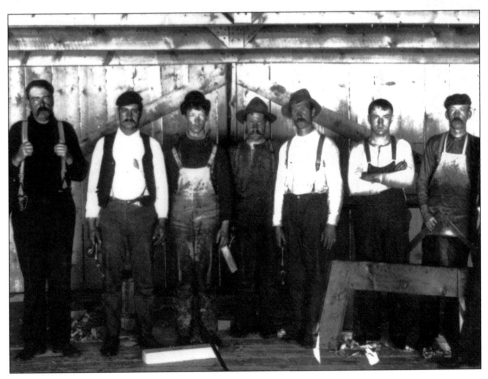

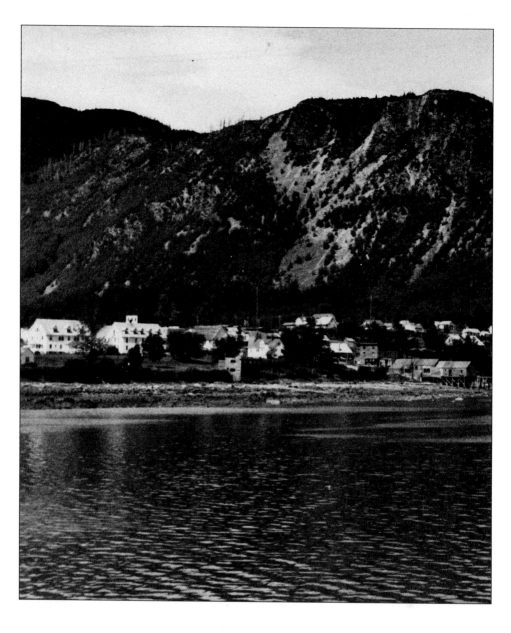

Above: A view of scenic Haines from the Lynn Canal.

Opposite: Members of the Skagway Gastronomic Club at a picnic lunch at Haines. July 31, 1899.

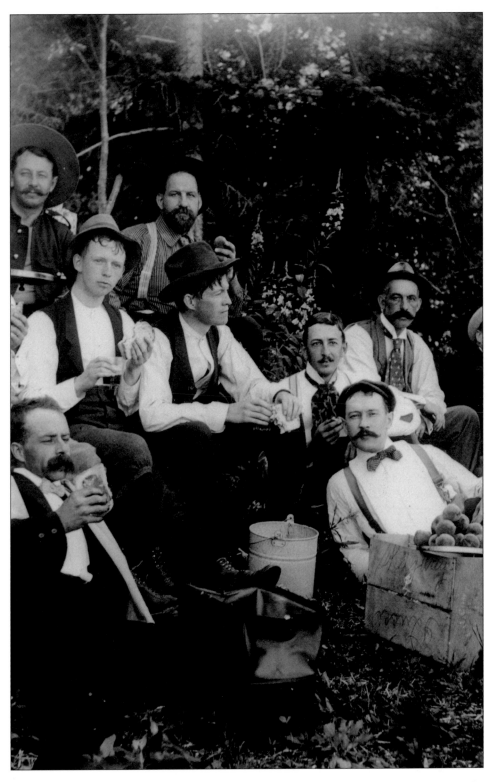

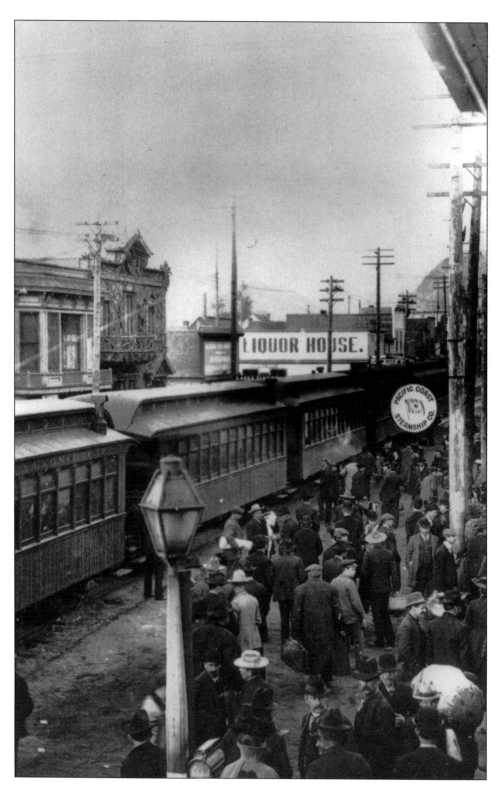

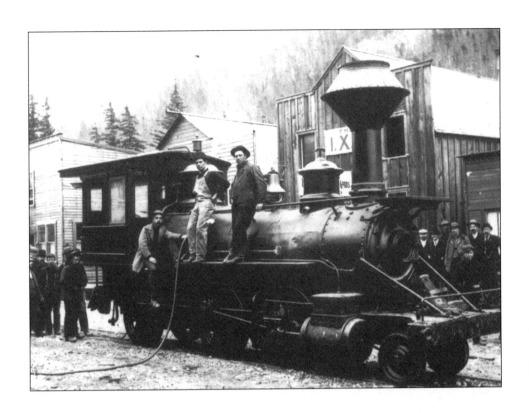

Opposite: A large group of passengers prepares to climb aboard the White Pass and Yukon Route Railway train stopped in front of the Skagway depot on Broadway near Second Avenue. The Arctic Brotherhood Lodge is visible across the street.

Above: Men posing on the first locomotive to arrive in Skagway. July 20, 1898.

When the eyes of the wondering world were turned to the new land of gold in the far north, when the rush to Klondike made towns grow in a week, Skagway was born and built a few miles from Dyea, which proudly claimed rank of a great and everlasting city.

But in two year's time Dyea was depopulated and dead - as dead as the old city of the cave dwellers in Arizona - and Skagway was a thriving town with a great wharf, a railroad and possessed of all the institutions which go to make a modern city. And Skagway will always be there, the natural gate opening up to the empire beyond. A hundred thousand square miles and more can be reached over Skagway only, and these vast regions bear promises of future discoveries of gold and copper, of coal and a host of other mineral products, besides millions of acres that some day will be claimed as homes of thousands.

Elias Ruud, Alaska Monthly Magazine, May 1907

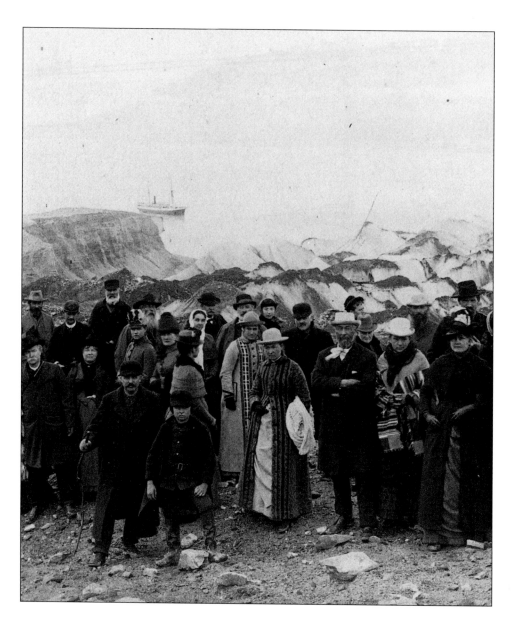

We were in the midst of strange scenes, hard to render in words, the miles upon miles of moraines upon either hand, gray, loosely piled, scooped, plowed, channeled, sifted...the sparkling sea water dotted with blue bergs and loose drift ice, the towering masses of almost naked rock, smoothed, carved, rounded, granite-ribbed and snow-crowned that looked down upon us from both sides of the inlet.
John Burroughs, *Alaska, The Harriman Expedition, 1899*

Above: A group of tourists pose on the Muir Glacier with a ship offshore. Tourism in Southeast Alaska grew after John Muir made voyages to the area in 1879 and 1880 and published articles about the beauty of the scenery.

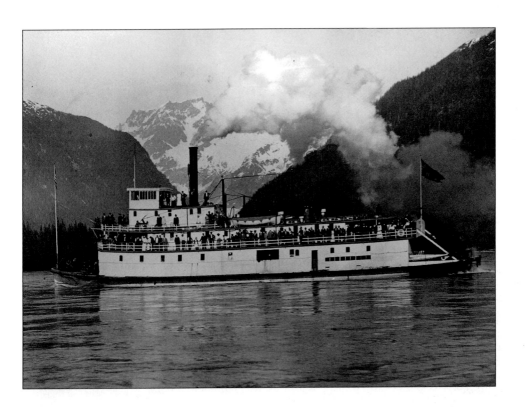

Above: The SS "Port Simpson", a paddlewheeler, on the Stikine River with Great Glacier in background. The conservationist and writer John Muir traveled on a ship like this up the Stikine River more than a hundred miles inland to Glenora, British Columbia.

Pages 94 and 95: Fortunately, when the SS "Princess May" went aground on August 5, 1910, no lives were lost. At low tide, photographers were able to compose an unusual image. At high tide the ship was towed safely off the reef, and after costly repairs, was returned to service.

The Barrington Transportation Company closed its nineteenth successful season of water transportation between Wrangell, Alaska and Telegraph Creek, in the Cassiar district of Canada, this year. The river boats on the Stikine travel up a beautiful but treacherous stream, sometimes filled with high water and ice and other times low and strewn with sand-bars. In spite of this the Company has built an enviable record of not having lost a pound of freight, a sack of mail or a passenger.
Alaska Sportsman, January 1936

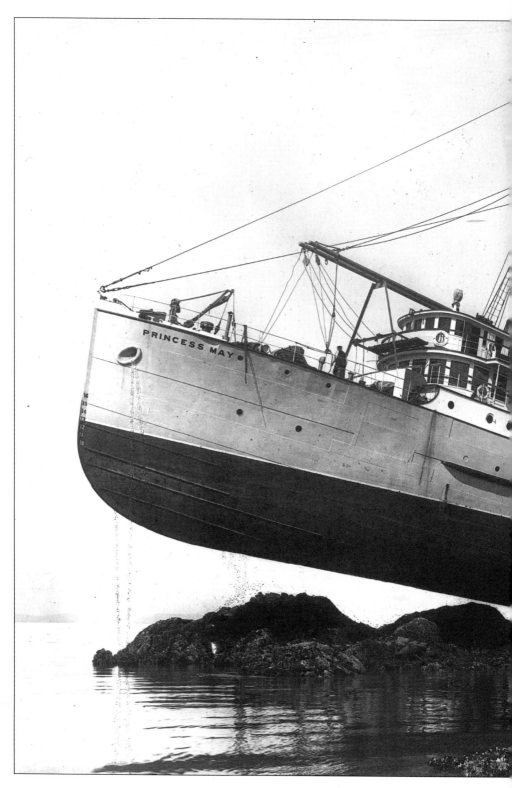

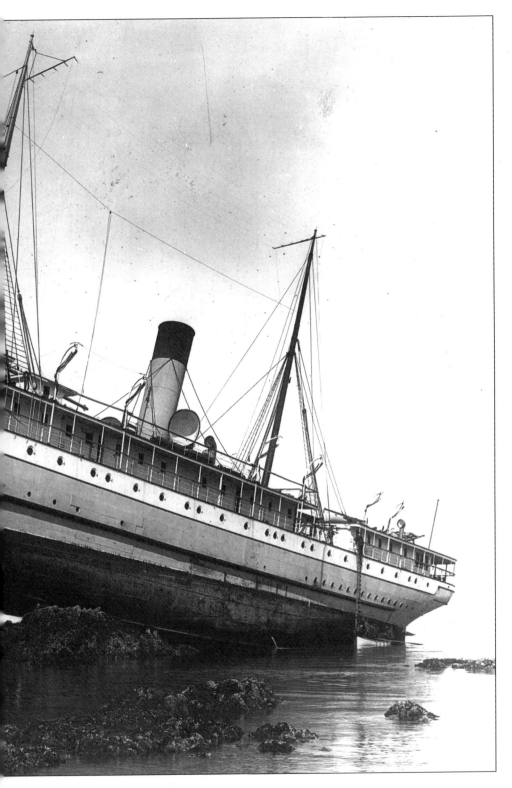

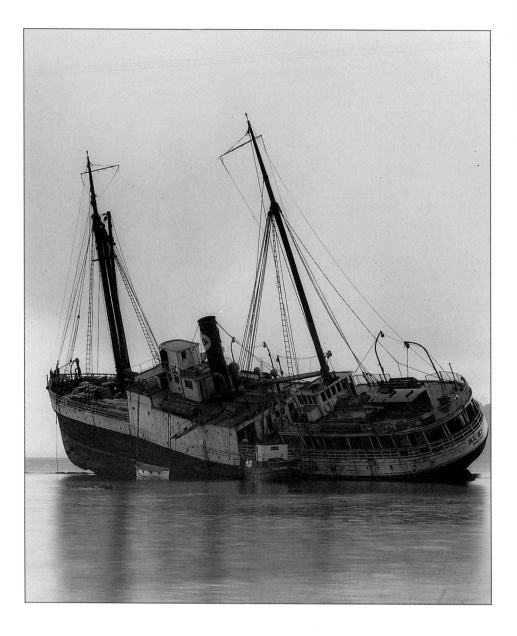

The steamer was certainly a has-been. She was dirty, and loaded to the gunwales with passengers, animals and freight. Men slept on the floor of the saloon and in every corner... The captain was seldom, if ever, sober, and there were many wild parties. ... Our safe arrival in Skagway was due probably to the Guiding Hand that looks after children, fools and drunken men.
Martha Louise Black, 1938, writing about her journey to Skagway in 1898

Above and Opposite: The SS "Alki" went aground on November 1, 1917 on Point Augusta, near Juneau. Salvage was impractical and the ship gradually disintegrated. In the days before radar, dense fog and snowstorms resulted in many disasters.

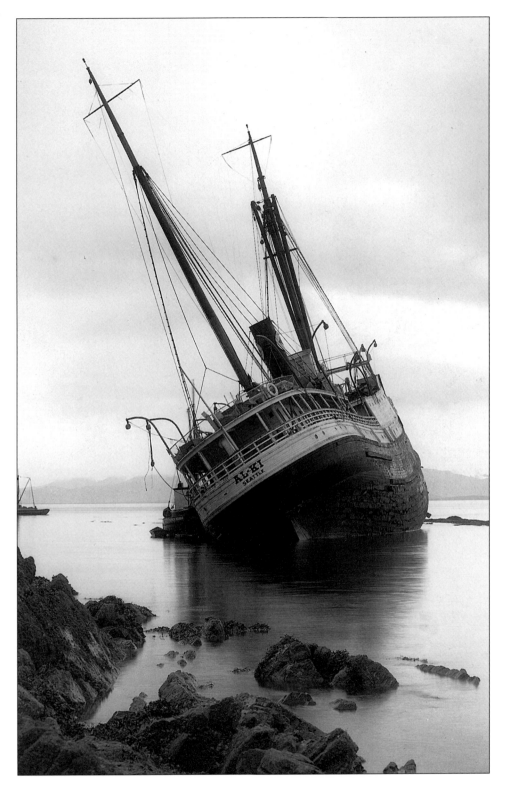

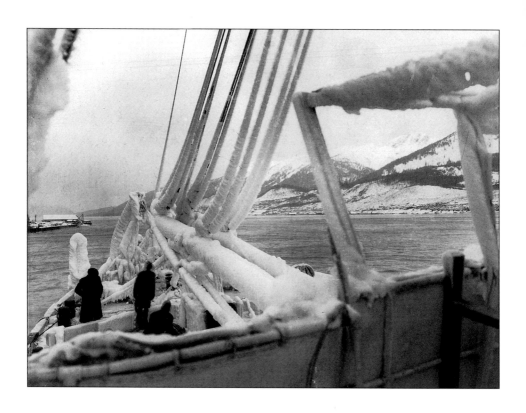

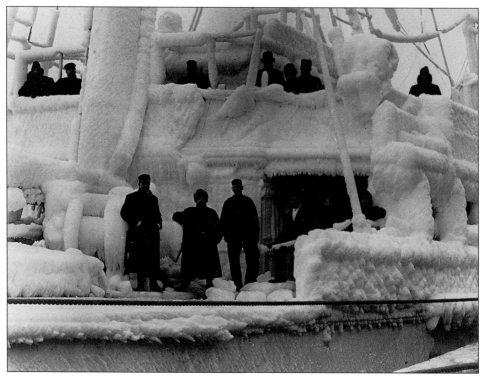

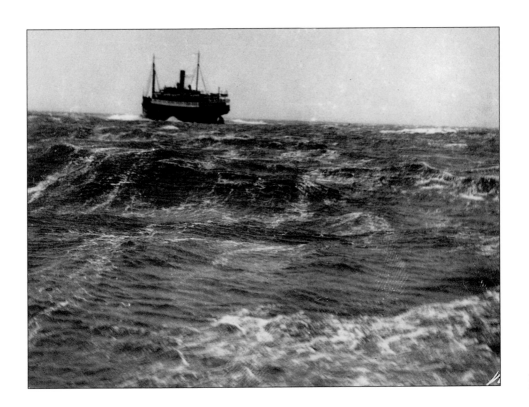

Opposite: Winter navigation in Southeast Alaska posed many hazards. Blizzards not only created navigation dangers but could also encrust a ship in ice.

Above: The sinking of the steamer "Princess Sophia" on October 26, 1918 claimed 353 lives. The "Princess Sophia" was traveling from Skagway in a snow storm when it went aground on Vanderbilt Reef near Juneau. The steamer was pounded on the reef for a day and a half as is shown in this photograph. Rescue ships circled but were unable to remove any passengers because of the storm and the treacherous reef. The rescue ships reluctantly sought sheltered harbor for the night hoping the storm would break by morning. When they returned at first light, all that remained of the "Princess Sophia" was the mast jutting from the icy waters. There were no survivors.

It's storming now, about a 50 - mile wind and we can only see a couple of hundred yards on account of the snow and spray. At three A.M. yesterday she struck a rock submerged at high tide, and for a while there was some excitement, but no panic. Two women fainted and one of them got herself into a black evening dress and didn't worry over who saw her putting it on. Some of the men, too, kept life preservers for an hour or so and seemed to think that there was no chance for us.... We had three tugboats here in the afternoon, but the weather was too rough to transfer any passengers. The most critical time, nobody but the ship's officers, we soldiers and a few sailors amongst the crew and passengers were told of it, was at low tide at noon when the captain and chief officer figured she was caught on the starboard bow and would hang there while she settled on the port side and astern. They were afraid she would turn turtle, but the bow pounded around and slipped until she settled into a groove, well supported forward on both sides. The wind and the sea from behind pounded and pushed her until she is now, 30 hours after, on the rock clear back to the middle and we can't get off.

Auris McQueen, from a letter written to his mother hours before all 353 aboard the Princess Sophia were to die. October 25, 1918.

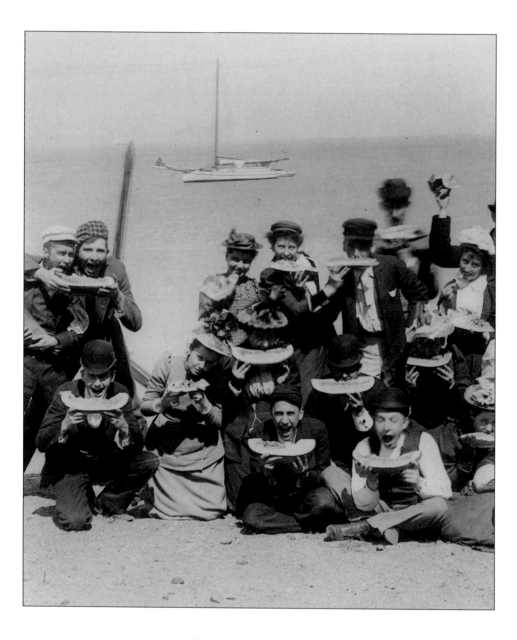

Above: Partiers enjoying watermelon on a beach. Southeast Alaska has benefited from its relatively easy access to world markets. Compared to many places in the north, Southeast Alaska has had a range of goods, especially fresh produce, of great diversity and freshness.

Opposite Top: The SS "Jefferson" sightseeing at the Taku Glacier near Juneau. Excursions on steamships increased in popularity following the publication of the writings of John Muir.

Opposite Bottom: The "Princess Royal" in the Gastineau Channel near Juneau.

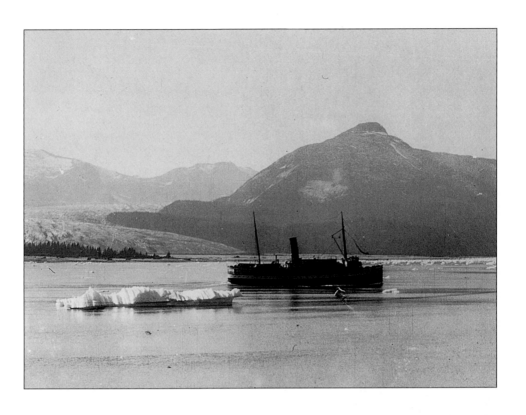

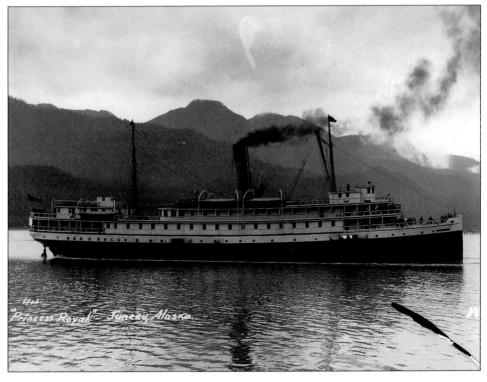

"Princess Royal" Juneau, Alaska.

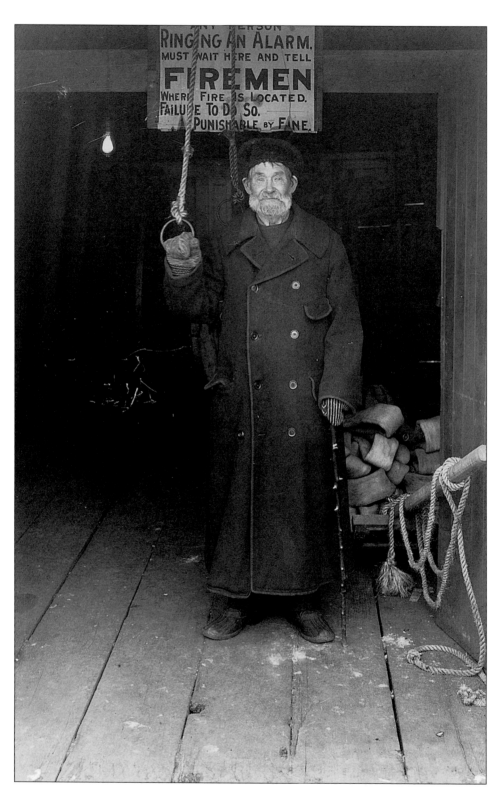

JUNEAU

By 1880 a mining camp was established which would later be known as Juneau. Several small creeks around the camp were producing gold and many residents were preparing for a Bonanza. The town had few permanent buildings and most residents lived in canvas tents. The mining was primarily placer claims which favored small-scale operations. Gravel was shoveled from streams, and gold was separated in either gold pans or sluice boxes. This surface gold was accessible but was relatively scarce. Few miners prospered.

Eventually the Treadwell Mine built a hard-rock mine and began processing the "Paris Lode" which was located deep underground. As with fishing, Chinese laborers were hired to work in the mine. This prompted much opposition from local residents in Juneau who held discriminatory opinions of the Chinese and the working conditions and low pay the Chinese accepted. This situation became more serious when a house which some Chinese inhabited was blown-up. Shortly afterwards a large group of residents forced the Chinese to board two ships and leave town. The mine never hired Chinese people again.

Opposite: A Juneau fireman stands in front of the fire hall.

The Treadwell Mine ensured Juneau's prosperity and growth. For decades it produced gold from what was considered a low-grade ore body. By 1885 Juneau's population had risen to almost 1500. The residents worked frantically to develop a city and did not want their town considered a mining camp. Where the dense rainforests ran up the steep hillsides, a city was carved. It was only a short time before the city had 30 saloons, restaurants, a hospital, schools, plumbing, electricity, telephones and all the amenities of any modern community anywhere. As the town grew it became the hub of operations of much of Alaska. In 1900, Congress decided to move the capital from Sitka to Juneau.

The economy of Southeast Alaska gradually matured and diversified. The two World Wars and the 1929 Depression greatly affected the region. These pressures

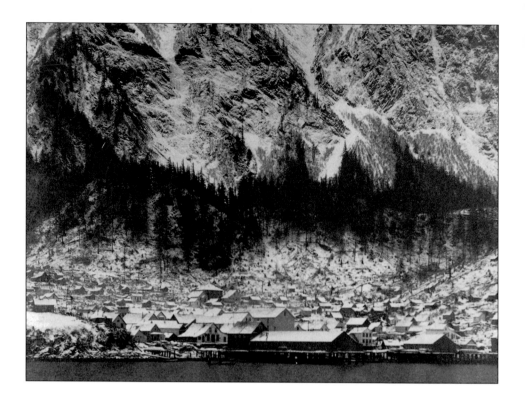

fostered greater independence and self-reliance for Southeast Alaska. Juneau provided a range of services to communities scattered throughout the Inside Passage. And while these smaller towns and communites were never mere satellites, they did benefit from the development of Juneau's service sector economy.

Above: Waterfront scene of Juneau, with Mount Juneau in the background. ca. 1897.

Opposite Top and Bottom: View of Juneau from Gastineau Channel. Much of the forest has been cleared and tree stumps ring the town. The mailboat Yukon is in view. ca. 1887.

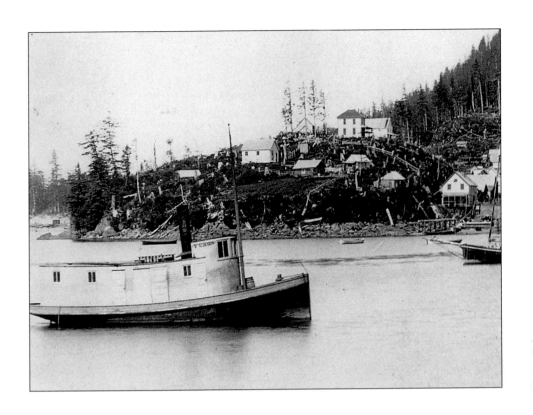

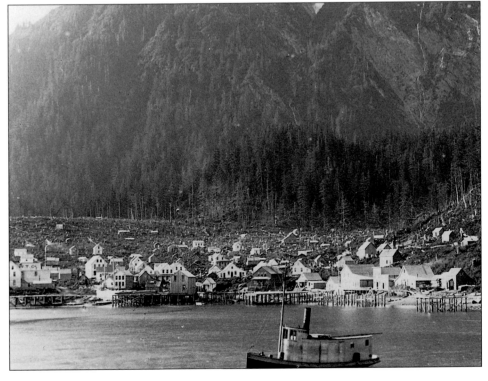

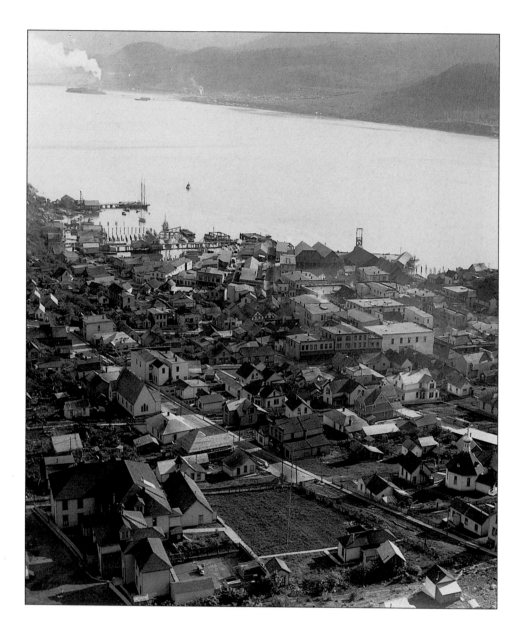

Juneau boasts itself, if not the capital, the metropolis of Alaska, for it can number some three thousand souls. It is the center for expeditions into the far Yukon mining territory, while within sight is the gaping pit of the famous Treadwell gold mine, with the largest stamp-mill in the world. Two hundred and forty stamps, required for crushing immense quantities of low-grade ore, make such a din that the chatter of the tourist dies out in hopelessness of a hearing.
Lucy M. Washburn, 1894

Above: Juneau quickly established itself as the largest city in Southeast Alaska.

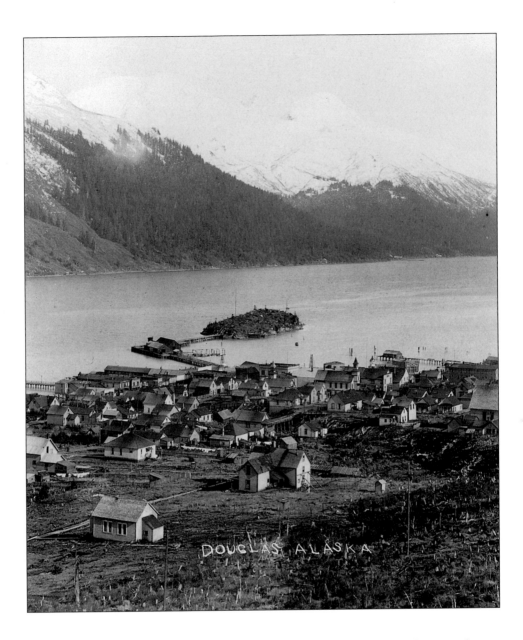

DOUGLAS ALASKA

Above: The town of Douglas, on the other side of the Gastineau Channel from Juneau, was located near the Treadwell mine. In its heydey, as many as two thousand miners were employed at this mine. The Treadwell mine operated until 1917 when a cave-in closed three of the mines four tunnels. ..By 1910, Douglas had a popula-tion of almost two thousand. The Treadwell mine housed an addi-tional twelve hundred employees. Douglas benefitted from high levels of employment and the relatively high wages the Treadwell mine paid.

Pages 108 and 109: Victrola salesmen and customers in Juneau.

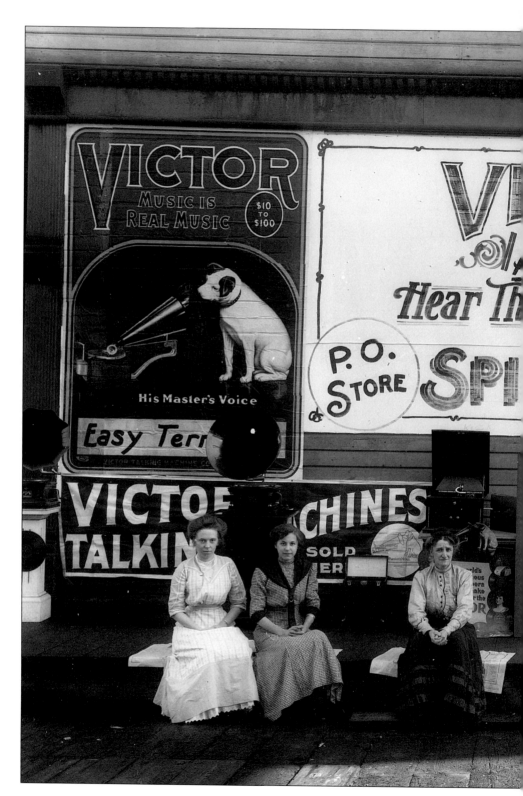

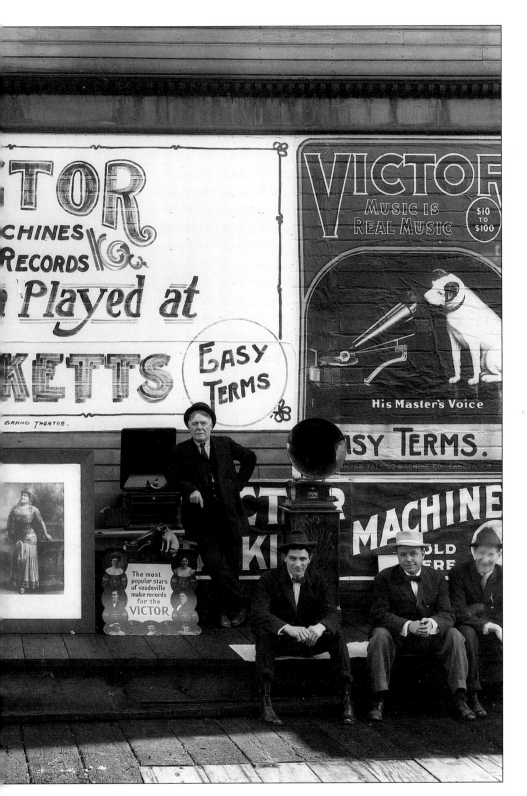

109

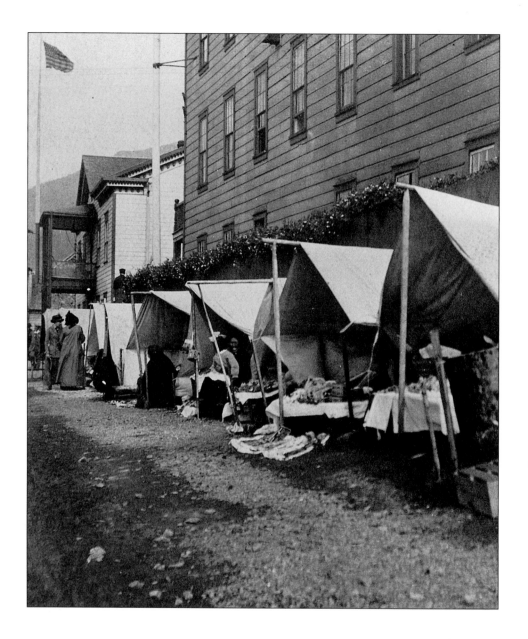

Tourists gain their main impressions of the natives from those at white settlements, reaping their sole harvest of coin for a long year by selling totem-marked articles, especially graceful spoons of translucent horn, bracelets beaten out of silver coin, and baskets woven of cedar rootlets, so fine and firm that they will hold water.
Lucy M. Washburn, 1894

Above: Indians sold their artwork and crafts in stores and at small stalls. Masks, baskets and beaded leatherwork were popular with tourists.

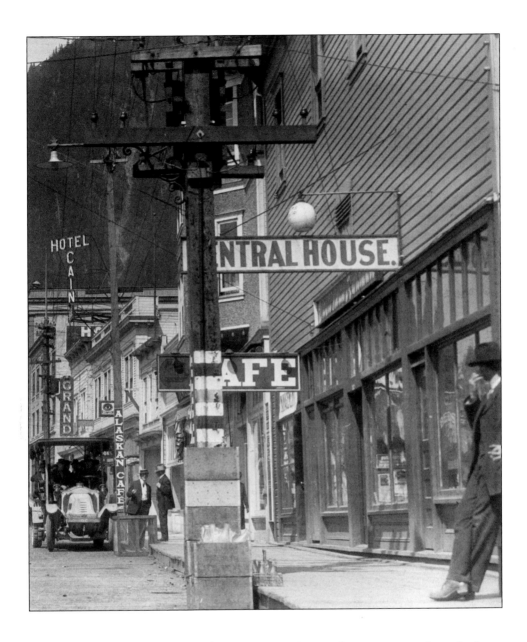

Above: Juneau street scene looking up Franklin Street from near Ferry Way.

Thousands of letters bearing five-cent stamps when only threes are required are sent to Alaska each year from the States. The error is made for the reason that many persons do not think Alaska as a territory of the United States, but believe it a foreign country. Another common error, even among post office clerks, is the belief that parcel post packages may not be sent to Alaska during the winter.
Alaskan Sportsman, January 1936

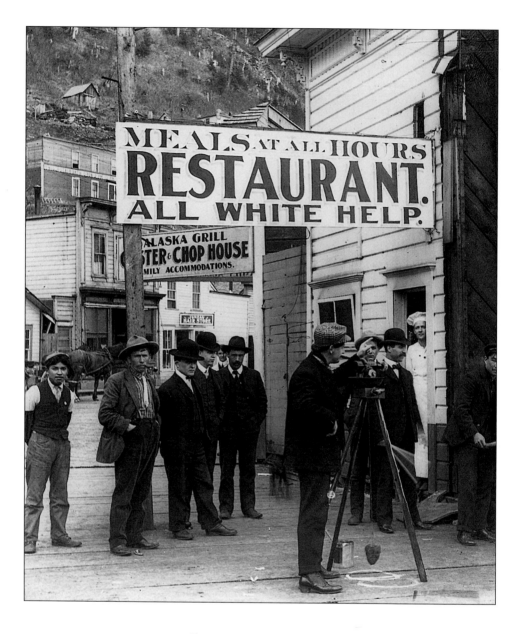

Above: A surveyor in a humorous mood has replaced his transit with a beer bottle. Less humorous is the sign above advertising "All White Help." This blatant racism was directed to both Native and minority groups such as the Chinese.

Opposite: A street scene at night in Juneau. Snow - covered electrical wires criss-cross the street.

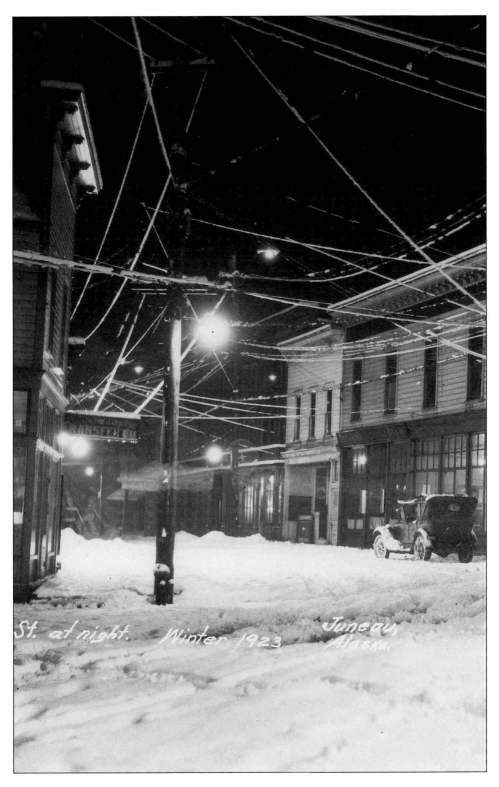

St. at night. Winter 1923 Juneau, Alaska.

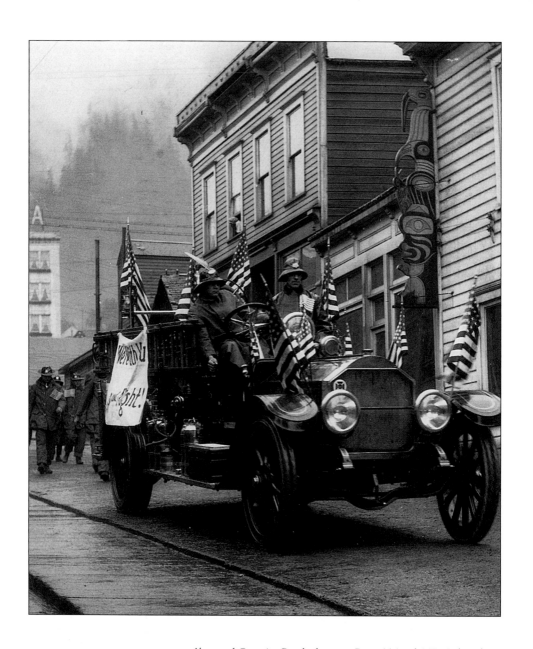

Above and Opposite: Parades have always been very popular in Southeast Alaska. In the early days horses pulled wagons which were decorated. Cars and trucks were later used. The Fourth of July was always the most elaborate parade of the year.

Pages 116 and 117: Girls with wands, crowns and costumes with stars. Clubs have always been extremely popular in Southeast Alaska for both children and adults.

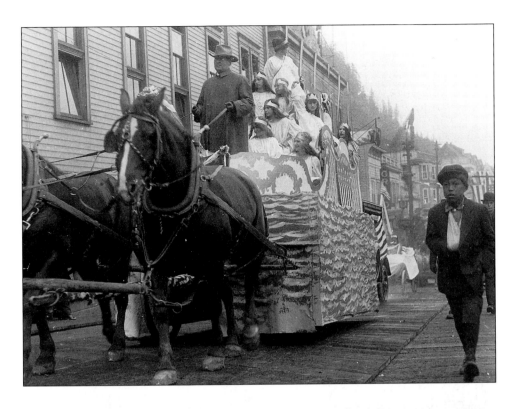

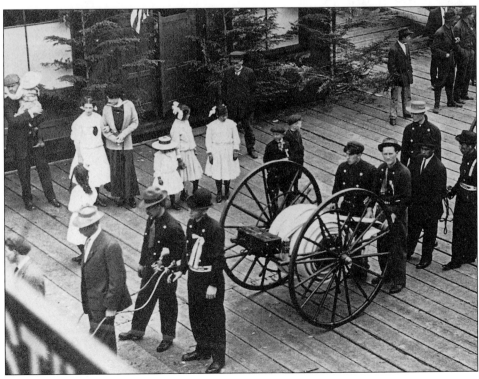

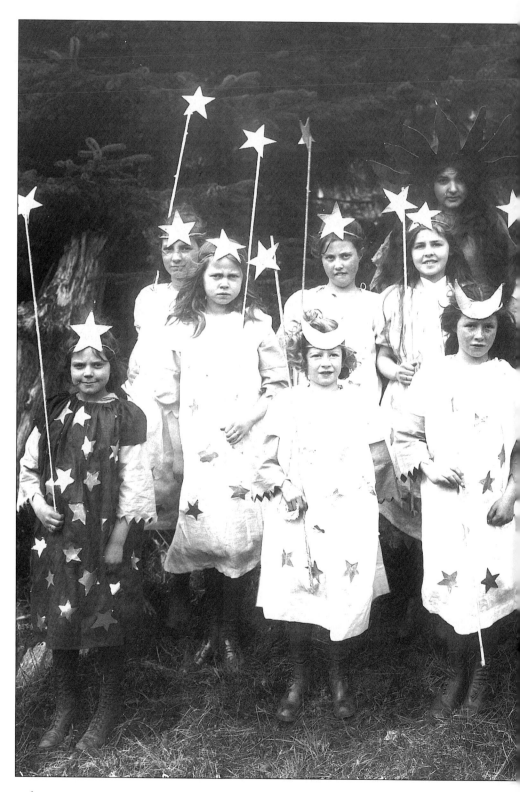

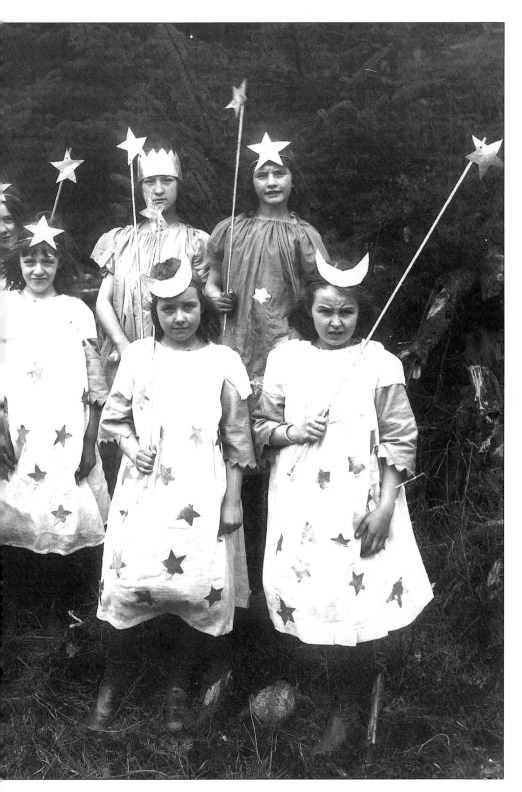

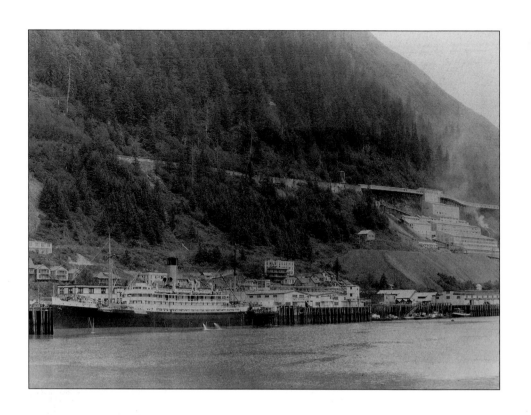

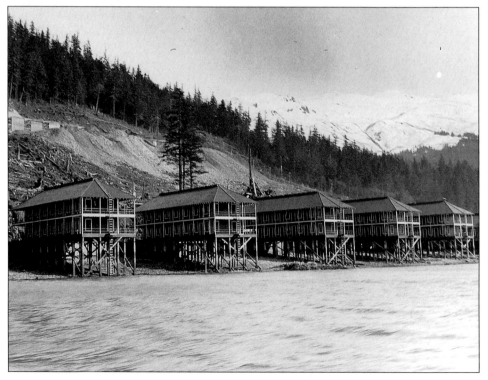

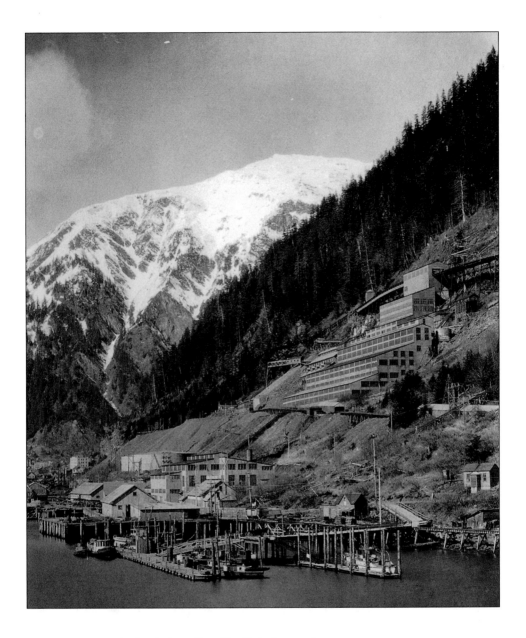

Opposite Top: Juneau has benefited from its natural harbor.

Opposite Bottom: These housing quarters were built on pilings over the Gastineau channel at Thane, just outside Juneau. These residences provided for workers at the Alaska-Juneau mine.

Above: The Alaska-Juneau mine was well known for its huge stamp mill. Large chunks of ore-bearing rock are crushed in the stamp mills, and the crushed ore is then processed in an acid bath.

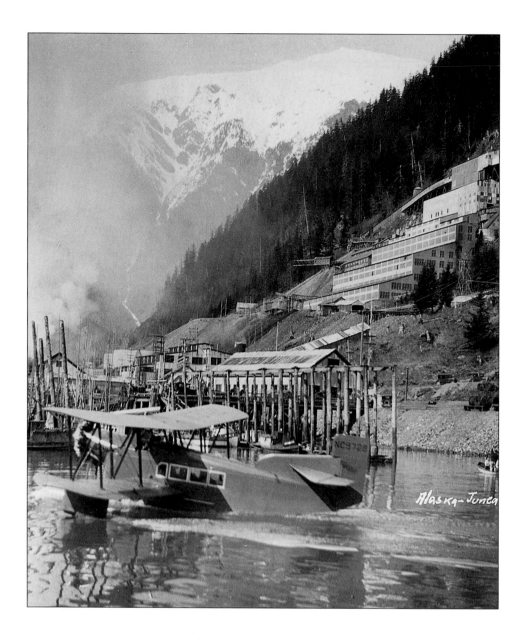

Above: A biplane on floats taxis in front of the Alaska-Juneau mine.

Opposite Top: A group of fishers pose with a large collection of trout. Fly-in fishing at small mountain lakes was common in Southeast Alaska.

Opposite Bottom: A rowing regatta on the Gastineau channel. These races were very competitive and were a popular spectator sport.

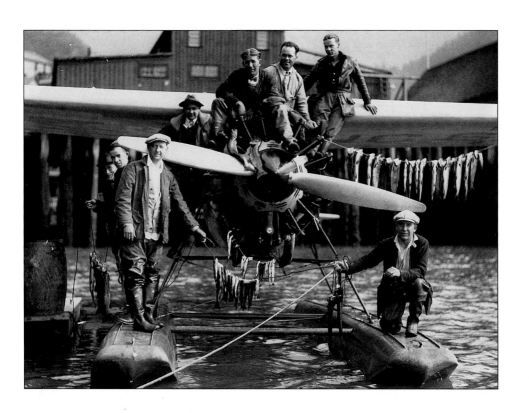

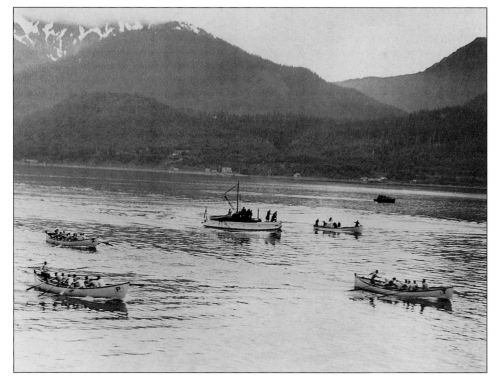

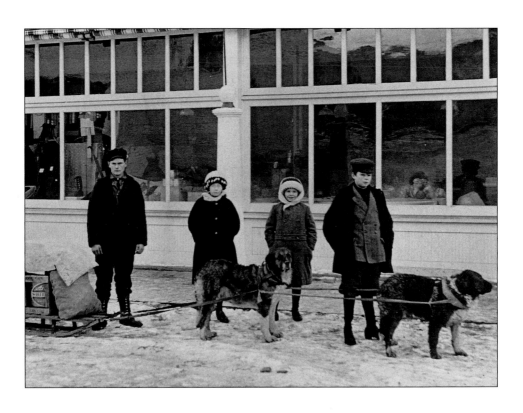

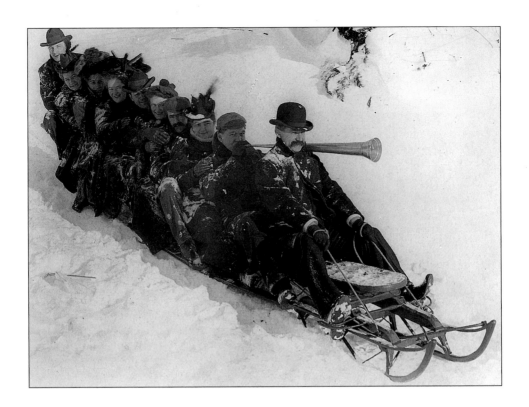

Opposite Top: In winter, sleds were used to haul groceries as well as for fun.

Opposite Bottom: A winter scene in Juneau, looking up Franklin Street just south of Front Street.

Above: This photograph was intended for use as a Christmas card. Recreation made winters more enjoyable and sledding and skating were popular in Southeast Alaska.

There are possibly 300 white people in town. The store of the Northwest Trading Company is conspicuous among the others, but there are good restaurants, two drug stores and several general stores, a beer brewery, two barber shops with hot and cold baths, a jeweler's shop, blacksmith's shops, post office and some very snug dwellings.
Charles Hallock, 1885

Above: Eight men pose at a creek near Juneau. Social clubs and lodges were popular.

Opposite: Masonic Grand Lodge officials attending the "corner stone" ceremonies for a new public school in Juneau. June 5, 1917.

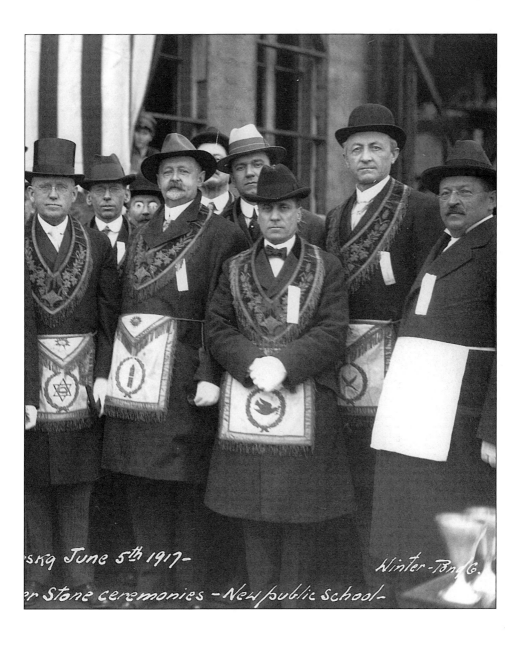

...sky June 5th 1917 –

Winter - Bnd C.

...r Stone ceremonies – New public school –

Chronology of Significant Dates in Southeast Alaska

15,000 Before Present: The Bering Land Bridge allows Asians access to Alaska.

8,000 Before Present: Prehistoric peoples migrate along the Yukon River to North America.

1786: French navigator Jean-Francois La Perouse, seeking the Northwest Passage, explores Southeast Alaska and encounters the Tlingit.

1794: The British explorer George Vancouver skirts Admiralty Island.

1799: Alexander Baranof builds Fort St. Michael, six miles north of modern Sitka.

1802: Tlingit warriors destroy Redoubt St. Michael.

1804: Baranof returns from Kodiak and restakes the Russian claim to the Sitka area.

1834: The Russians build a stockade, Fort Dionysius, to control fur trade up the Stikine River.

1840: Fort Dionysius becomes Fort Stikine, a British post, when the Russians lease Southeast Alaska to the Hudson's Bay Company.

1845: An Orthodox mission school opens at Sitka.

1857: The Grand Duke Constantine urges the sale of Russian Alaska to the United States.

October 1867: Russian Alaska is purchased by the United States.

1869-70: The Alaska Times, the Territory's first newspaper to be printed in Alaska, is published in Sitka.

1877: The first American school in Alaska is established at Wrangell.

1878: Alaska's first salmon canneries are established at Old Sitka and Klawock.

1880s: Potlatches are outlawed; Tlingit arts and dancing fall into decline.

1880: A mining camp called Harrisburg is established. It is later re-named Juneau.

1881: Presbyterian missionary S. Hall Young establishes Haines.

1897: "Peter's Burg" is founded when Peter Buschmann begins a salmon cannery and sawmill.

July, 1898: The first boats of the Klondike stampede land at Skagway and nearby Dyea.

July, 1900: The White Pass and Yukon Route Railway reaches Whitehorse.

1906: The state capital is moved from Sitka to Juneau.

1907: George Emmons' *Notes on the Chilkat Blanket* are published.

1917: The Treadwell Mine (located on Gastineau Channel in Douglas across from Juneau) closes after the underwater tunnels flood and collapse.

1917: Franz Boas publishes *Grammatical Notes on the Language of the Tlingit Indians*.

1922: The state's first pulp mill begins operating at Speed River near Juneau.

1949: Alaska Indian Arts begins to revive Tlingit arts and crafts at Haines.

1951: Alaska's anti–potlatch law is repealed.

Photograph Credits

This book is largely the result of the excellent care and preservation of images a hundred years old. Collections at the Alaska Historical Library, Juneau were used extensively.

Alaska and Polar Regions Department, University of Alaska Fairbanks
67 (#58-1026-1538N)

Alaska State Library, Juneau, Alaska
Front Cover (PCA 87-50), 4 (PCA 87-50), 7 (PCA 87-107), 8/9 (PCA 87-10), 10 (PCA 87-17), 11 (PCA 01-2293), 12/13 (PCA 87-50), 14 (PCA 01-1595), 15 (PCA 126-19), 16/17 (PCA 87-90), 18 Top (PCA 88-55), 18 Bottom (PCA 27-5), 19 (PCA 88-51), 20 (PCA 88-44), 21 (PCA 01-427), 22 (PCA 87-1), 23 (PCA 87-45), 24 (PCA 87-237), 25 (PCA 87-39), 26 (PCA 87-8), 27 (PCA 01-117), 28/29 (PCA 87-21), 30 (PCA 01-1959), 32 (PCA 27-48), 33 (PCA 01-113), 34/35 (PCA 27-105), 36 (PCA 01-213), 37 Top (PCA 102-42), 37 Bottom (PCA 102-42), 38 (PCA 102-43), 39 (PCA 87-1153), 46 (PCA 66-444), 48 Top (PCA-66-61), 48 Bottom (PCA 66-63), 50 (PCA 01-33), 60/61 (PCA 39-843), 70 (PCA 01-529), 72, 73 (PCA 01-319), 78/79 (PCA 01-477), 80 (PCA 88-29), 81 (PCA 66-286), 82 (PCA 87-1557), 83 (PCA 01-820), 84 (PCA 01-160), 85 (PCA 01-1601), 86 (PCA 88-33), 88/89 (PCA 87-1689), 90 96 (PCA 87-1581), 97 (PCA 87-1582), 98 Top (PCA 87-1635), 98 Bottom (PCA 87-1638), 99 (PCA 87-1706), 100 (PCA 87-2792), 101 Top (PCA 87-1610), 101 Bottom (PCA 87-1697), 102 (PCA 87-1185), 104 (PCA 01-812), 105 Top (PCA 88-6), 105 Bottom (PCA 88-60), 106 (PCA 87-753), 107 (PCA 87-2810), 108/109 (PCA 87-1036), 110 (104-23), 111 (PCA 31-20), 112 (PCA 87-1050), 113 (PCA 87-1060), 114, (PCA 87-1197), 115 Top (PCA 31-52), 115 Bottom (PCA 66-69), 116/117 (PCA 87-945), 118 Top (PCA 87-854), 118 Bottom (PCA 31-93), 119 (PCA 87-517), 120 (PCA 87-1088), 121 Top (PCA 87-1092), 121 Bottom (PCA 87-1211), 122 Top (PCA 104-27), 122 Bottom (PCA 31-24), 123 (PCA 87-1258), 124 (PCA 87-2789), 125 (PCA 87-938), 128 (PCA 87-55), Back Cover (PCA 87-1689)

British Columbia Archives and Records Service, Victoria, B.C.
58 Bottom (A-551)

Tongass Historical Society, Ketchikan, Alaska
40 (#73.3.16.32), 43 (#73.3.16.3), 44 (#73.3.16.135), 45 (#73.3.16.27), 47 (#73.3.16.31), 49 (#73.3.16.65), 51 (#73.3.16.146), 74/75 (#86.1.3.91), 76 (#62.4.3.20), 77 Top (#62.4.1.157), 77 Bottom (#62.9.1.85),

Washington State Historical Society, Tacoma, Washington
62 (46112), 63 (46110)

Yukon Archives, Whitehorse, Yukon
54 (2311), 57 (2314), 58 Top (2445), 59 (4269), 64 (2303), 65 (4458), 66 Top (3626), 66 Bottom (1196), 68 (2711), 69 (5346), 86 (4871), 87 Top (4874), 87 Bottom (4873), 88 (3857),

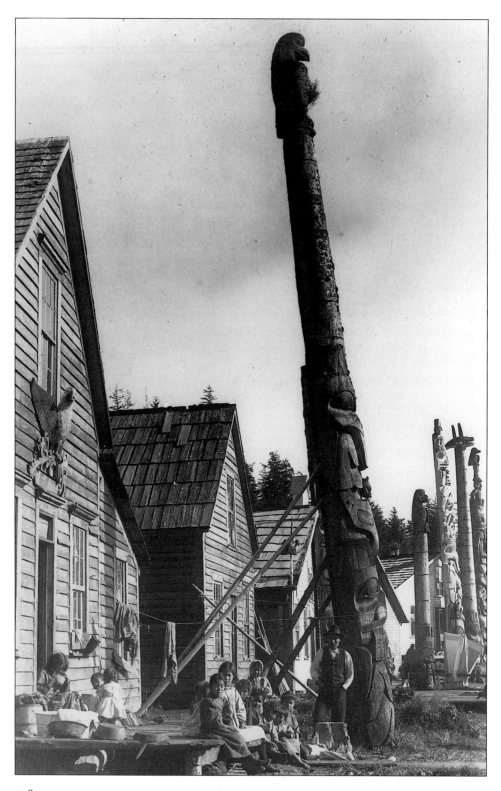